android
photography

A Guide to Mobile Creativity

android
photography

Jolie O'Dell

PIXIQ™

An Imprint of Sterling Publishing Co., Inc.
New York

Android Photography

Library of Congress Cataloging-in-Publication Data

O'Dell, Jolie A., 1982–
 Android Photography: A Guide to Mobile Creativity / Jolie Anne
O'Dell. -- 1st ed.
p. cm.
ISBN 978-1-4547-0346-4
1. Photography—Amateurs' manuals.
2. Photography, Artistic—Amateurs' manuals.
3. Photography—Digital techniques—Amateurs' manuals.
4. Android (Electronic resource)—Amateurs' manuals. I. Title.
TR146.O26 2012
770--dc23
 2011026775

10 9 8 7 6 5 4 3 2 1
First Edition

Published by Pixiq,
A Division of Sterling Publishing Co., Inc.
387 Park Avenue South, New York, N.Y. 10016

Text © 2012 The Ilex Press Limited
Photographs © 2012 Jolie Anne O'Dell unless otherwise specified
Android ™ and the Android Robot are trademarks of Google, Inc.

Distributed in Canada by Sterling Publishing,
c/o Canadian Manda Group, 165 Dufferin Street
Toronto, Ontario, Canada M6K 3H6

If you have questions or comments about this book, please
contact:
Pixiq
67 Broadway
Asheville, NC 28801
(828) 253-0467
www.pixiq.com

Manufactured in China
All rights reserved

ISBN 13: 978-1-4547-0346-4

For information about custom editions, special sales, premium
and corporate purchases, please contact Sterling Special Sales
Department at 800-805-5489 or specialsales@sterlingpub.com.
For information about desk and examination copies available to
college and university professors, requests must be submitted
to academic@larkbooks.com. Our complete policy can be found
at www.larkcrafts.com.

CONTENTS

INTRODUCTION

The fascinating, colorful and addictive world of Android photography is a playground for the visually inclined as well as the technologically curious. It's half phantasmagoric wonderland, half algorithmic puzzle; it can be as complex and fulfilling as darkroom development and as simple and delightful as the point-and-click of a shutter button.

What makes Android photography so unique is the freedom inherent in the Android ecosystem. Android owners get a huge choice of devices, as well as the freedom to choose from hundreds of apps for photography alone. This book will guide you through this vast expanse of hardware and software.

One of the coolest things about the Android universe is its diversity of gadgets and operating systems. True, some would call the fragmentation of OS versions and devices confusing, but the benefits far outweigh the drawbacks. The variety of Android mobile hardware spans a plethora of devices with varying price points, features, capabilities, and even wireless networks, giving you, the end user, an enormous range of gadgets from which to choose.

And if you're interested in mobile photography, an Android smartphone is almost guaranteed to be your best bet when shopping for a mobile device. Android devices have some of the biggest and best cameras on the market. In fact, at the high end, you can find 8-megapixel and even 14-megapixel cameras.

Aside from hardware, Android photographers also have the benefit of a completely open marketplace of camera tools. This means you will be able to use lots of unique, subtly different photo apps that allow for more creative self-expression than you'd ever find in a single-device, closed-market mobile ecosystem.

And when it comes to sharing your photos, Android-created images have the size and quality to beautifully show off your creativity even in larger formats. You can share thumbnails on Twitter or Facebook, and you can also create a dazzling photo blog using a Tumblr or WordPress theme—all without sitting down at a PC to upload your images.

Android smartphones have also been great for shooting video for some time now. Toward the end of this tome, we'll dip our toes into capturing video—both live-streaming and recorded—on your Android device.

Finally, you'll get some tips from true mobile photography experts and a full list of resources to tay current on the best apps, gadgets and trends in Android photography.

HARDWARE

The Best Devices for Mobile Photography

Most top-of-the-line Android cameras are decent replacements for a point-and-click camera in almost every scenario you could imagine. Especially when the majority of your photos are going to end up online, where sizes are relatively small and pixel density isn't really an issue, Android-created images will hold their own next to most traditional camera snaps.

One thing to be aware of when you're selecting an Android device is that for most images and most online media, no one is going to be able to tell the difference between an 8-megapixel shot and a 5-megapixel shot.

The larger camera will take larger photos, but these photos will also take up more space on your camera and take longer to upload over a wireless connection. And by the time images are resized for Facebook and Flickr, they'll look about the same as a lower-resolution shot, anyhow.

So buy a device that meets your needs in every other way, and don't be fooled into thinking that more megapixels is the answer to great photos. Like horsepower in a car's engine, sometimes less is all you need and more is just added expense.

DROID X

With native cropping, rotating, and geotagging, this smartphone was built for on-the-go photography. And the Droid X's microSD card will hold up to 32GB of photos and other data; you can extend that storage up to a full 40GB, if needed.

Being a newer model with top-of-the-line hardware and a fast microprocessor, the Droid X also plays nicely with almost every photography app you'll find in the Android Market.

Droid X

Camera: 8 megapixels, digital zoom, auto focus
Flash: Dual LED
Video: 720p
Front-facing camera: Not available
Screen size: 4.3 inches
Operating system: Ships with Android 2.1
Network: Verizon

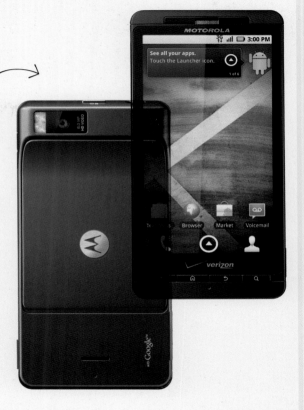

PROS: The Droid X shoots especially great video, with a crisp picture and clear sound even in crowded environments, thanks to the device's three noise-cancelling microphones.

CONS: Without a front-facing camera, you're stuck on the shy side of the camera, both for video and for photography. Shooting in dark environments can also be a little tricky in spite of this model's bright, dual LED flash; and we've noticed that at their full resolution (which you'll rarely see, since it's bigger than most computer screens), the big Droid X photos can be a bit fuzzy or blurry.

HARDWARE

HTC EVO 4G

This big, beautiful phone is a photo device first and a video-shooting device second. The images it takes are huge and, if you're shooting correctly, pixel-perfect. The phone comes with an 8GB memory card and 1GB of onboard ROM; it also has an HDMI out for quicker data transfers. Other features include editing tools, including manual settings for ISO and white balance, and superb Flickr integration for sharing multiple photos at once.

HTC Evo 4G

Camera: 8 megapixels, auto focus
Flash: 2x LED
Video: HD 720p
Front-facing camera: 1.3 megapixels, fixed focus
Screen size: 4.3 inches
Operating system: Ships with Android 2.1
Network: Sprint

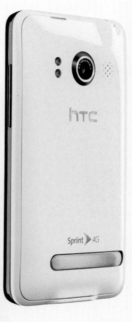
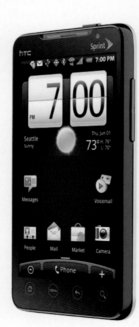

PROS: The Evo's super-sized screen means you'll get a much better idea of what your final images will look like before you press the "save" button.

CONS: The battery life on this model is regrettable, especially if you're running power-sucking camera and editing apps. Buy and charge an extra battery for photo excursions, and make sure you keep a charger on your person at all times.

SAMSUNG GALAXY S

The base version of this phone has a plethora of variants, one for each of the major U.S. mobile carriers. Variants are also available for sale in several other countries, including Brazil, Canada, Japan, China, and Korea. Features differ only very slightly between models, with the front-facing camera and LED flash being the most notable variables.

In reviews, the Galaxy S phone's video-shooting capabilities have been particularly lauded.

Samsung Galaxy S

Camera: 5 megapixels, autofocus, smile detection
Flash: None (except Fascinate and Epic 4G)
Video: HD 720p
Front-facing camera: None (except Epic 4G)
Screen size: 4.0 inches
Operating system: Ships with Android 2.1 with 2.2 upgrade available
Networks: Verizon (Fascinate), T-Mobile (Vibrant and Galaxy S 4G), AT&T (Captivate), Sprint (Epic 4G), Cellular South (Showcase), U.S. Cellular (Mesmerize)

PROS: Being available on so many networks means that no matter what carrier you choose, you'll likely be able to easily switch to a Galaxy S model.

CONS: With limited flash options and a 5MP camera, your still photography experience may be slightly more challenging than if you opted for a higher-powered model. Still, for Facebook or Flickr photos shot in normal lighting, you likely won't be able to tell the difference.

HARDWARE

DROID INCREDIBLE

Like HTC's Evo, the Incredible (also from HTC) has lots of onboard features for tinkering with ISO, white balance, metering mode, and other settings. It was built for speed, so get ready for some swift snapping. The native camera app takes about a second to launch, so you'll be up and running quickly. Flickr also comes pre-loaded on these camera-heavy devices.

Droid Incredible (Desire in European markets)

Camera: 8 megapixels, auto focus
Flash: Dual LED
Video: 480p
Front-facing camera: None
Screen size: 3.7 inches
Operating system: Ships with Android 2.2
Network: Verizon

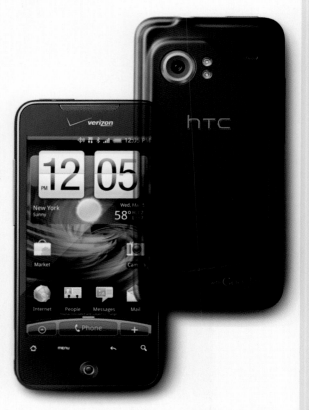

PROS: The Incredible has a quick focus, fast shutter speed and a huge camera, making it a good option for still photography, especially in situations where time is of the essence for capturing a moment.

CONS: The 3.7 screen means you'll see images at smaller sizes before you save them, and all those lovely camera-settings options means more opportunity to accidentally leave the Incandescent white balance on while shooting outdoors, rendering all your shots a ridiculous blue color, for example. Also, you won't get HD-quality video on this device.

DROID AND DROID 2

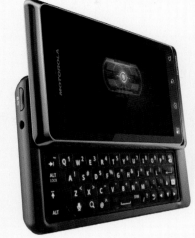

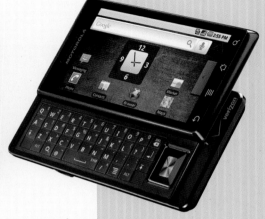

If you're a social photographer or if you plan to do a bit of photo-blogging with your new Android device, this is the absolute best model for you: It packs a decent camera and flash along with a physical keyboard for tagging, captioning, titling, describing, and posting your beautiful photos around the web. The Droid and its successor, the Droid 2, are remarkably similar, so whichever model you choose it won't make much of a difference to your photography. The phone also has settings for white balance and macro shots, so you'll have a bit more control over your photography. It also shoots good, clear video.

Droid and Droid 2

Camera: 5 megapixels, digital zoom, autofocus
Flash: Dual LED
Video: 720p
Front-facing camera: None
Screen size: 3.7 inches
Operating system: Ships with Android 2.2 for Droid 2
Network: Verizon

PROS: The physical keyboard and macro focus settings for photo bloggers and social media users who want to share, share, share everything they snap.

CONS: You lose three megapixels with this model, so keep that in mind if you're thinking of printing high-resolution hard copies of your photos. Low lighting may also present some obstacles.

HARDWARE

HTC THUNDERBOLT

This phone is the newest of the models we're including in this edition. As such, it includes all the latest bells and whistles available in a smartphone. From its huge 8MP rear-facing camera to its front-facing camera that's video-chat ready (courtesy of Skype) to its mighty 1.2GHz dual-core processor, it's one of the most powerful devices you'll find right now. Its dual mic system sets you up for good-quality sound if you're shooting video, which will be recorded in full 720p HD.

HTC Thunderbolt

Camera: 8 megapixels, auto focus
Flash: Dual LED
Video: HD 720p
Front-facing camera: 1.3 megapixels, video-capable
Screen size: 4.3 inches
Operating system: Ships with Android 2.2
Network: Verizon

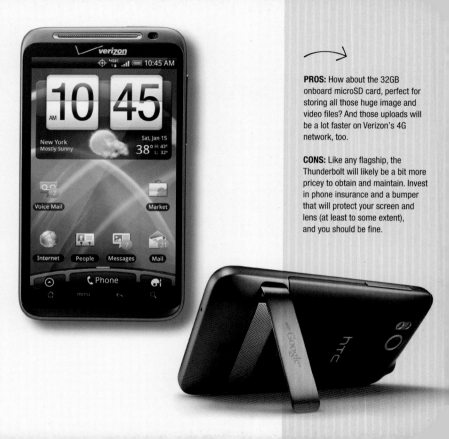

PROS: How about the 32GB onboard microSD card, perfect for storing all those huge image and video files? And those uploads will be a lot faster on Verizon's 4G network, too.

CONS: Like any flagship, the Thunderbolt will likely be a bit more pricey to obtain and maintain. Invest in phone insurance and a bumper that will protect your screen and lens (at least to some extent), and you should be fine.

THE DREAM PHONES

These are the devices for photographers who don't want to settle for camera phone quality. They're not widely available, and they're not available at all on U.S. carriers, but their specs are a taste of things to come between now and 2015.

SHARP ISO3

If you crave more megapixels, this phone delivers the goods. Once again, for most online uses, a few extra MPs won't necessarily translate to better images; still, if your image quality has to be excellent for special events, larger images, or printing hard copies, a camera phone like this one is the best option.

Sharp ISO3

Camera: 9.6 megapixels, autofocus
Flash: LED
Video: 720p
Front-facing camera: None
Screen size: 3.5 inches
Operating system: Ships with Android 2.1
Network: KDDI (Japan)

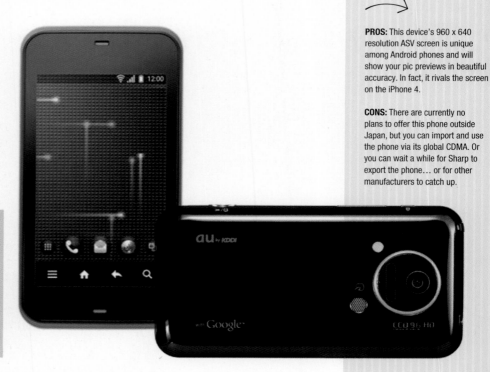

PROS: This device's 960 x 640 resolution ASV screen is unique among Android phones and will show your pic previews in beautiful accuracy. In fact, it rivals the screen on the iPhone 4.

CONS: There are currently no plans to offer this phone outside Japan, but you can import and use the phone via its global CDMA. Or you can wait a while for Sharp to export the phone… or for other manufacturers to catch up.

ALTEK LEO

This phone, if you could even call it that, comes from Chinese manufacturer Altek, which specializes in digital still cameras. The device itself has a conspicuous telescoping lens and looks for all the world like a legitimate camera with a smartphone on the back.

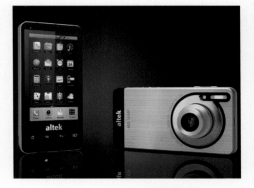

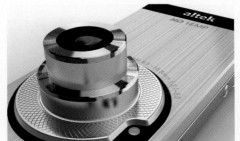

Altek Leo

Camera: 14 megapixels, 3x optical zoom
Flash: Xenon and video LED
Video: HD 720p
Front-facing camera: None
Screen size: 3.2 inches
Operating system: Ships with Android 2.1
Network: Various, Asia and Europe

PROS: 14 megapixels? Are you serious? With resolution like that, you could take print-worthy pics anywhere, anytime, with a device small enough to fit in your pocket.

CONS: For most markets, you can't buy it. If you do buy it, you might have a long and complicated unlocking process ahead of you, in which case you might as well just start carrying around a regular digital point-and-click camera. Also, the screen is a bit smaller than its stateside competitors' displays.

TECHNIQUE

How to Take the Best Mobile Shots

You can take a great photo with a fairly standard camera phone; you can take a rotten one with a top-of-the-line, 8MP device. In the end, it all comes down to your eye and your technique.

You'll still have some technical limitations—after all, you're working with a microscopic device embedded as a secondary hardware feature in a cell phone—but with a little photo-hacking, you can create breathtaking images of people, places and things with your Android phone.

If you'd like to save yourself a couple of months of bad photography and regrettable snaps, read up online on basic photo composition techniques, including the Rule of Thirds, the Golden Ratio, depth, framing, leading lines, and more.

And once you know the rules, feel free to break them. The opportunities for experimentation are practically unlimited for the mobile photographer.

PHOTOGRAPHY BASICS

The Rule of Thirds and Golden Ratios

In all photography, mobile and otherwise, a few basic compositional rules apply. The most canonical of these dicta is the Rule of Thirds.

The Rule of Thirds states that any image, including photographs and other design work, is naturally partitioned into nine sections along four lines that run the length and width of your picture, dividing it into thirds horizontally and vertically (see right). Each of these lines represents a potential strong visual focus of your photograph. The points at which the lines intersect are called "power points" and can be used to great effect to direct the eye to the most important elements of your image.

You can use the Rule of Thirds to take stronger pictures by visualizing these guiding lines as you set up a shot and positioning your subject or subjects where the lines run and especially where they intersect. Another easy way to roughly follow this rule is to imagine two lines, one running down the middle point horizontally and one splitting the photo down

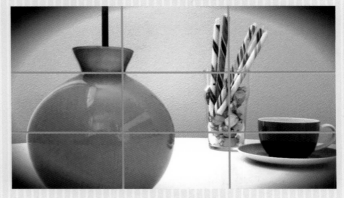

PHOTOGRAPHY BASICS

the middle vertically, together forming a plus sign in the center of your photo. Then, when you prepare to shoot, make sure your subject or subjects are not on one of these center lines.

We naturally tend to position our subjects in the center of the frame, but the Rule of Thirds shows us that more powerful and interesting photographs emerge when we slightly shift the subject to the left or right (or top or bottom) of the frame.

Another important concept to understand in composition is the Golden Ratio. This formula has been used in classical works of art and architecture for millennia and can be found in nature itself. It's a bit more mathematically complex than the Rule of Thirds, but it can lead to incredibly interesting and balanced photography.

Briefly, the Golden Ratio is approximately 1.618. This means that a rectangle constructed on the Golden Ratio (for example, one with a height of 1000 pixels and a width of 1618 pixels) can be divided into a square and another, smaller rectangle with

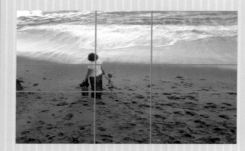

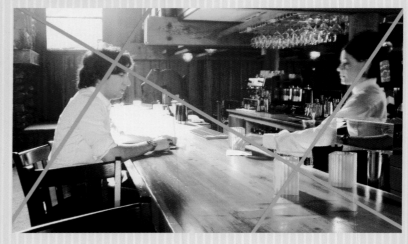

The Golden Ratio is more mathematically complex but yields fascinating photography.

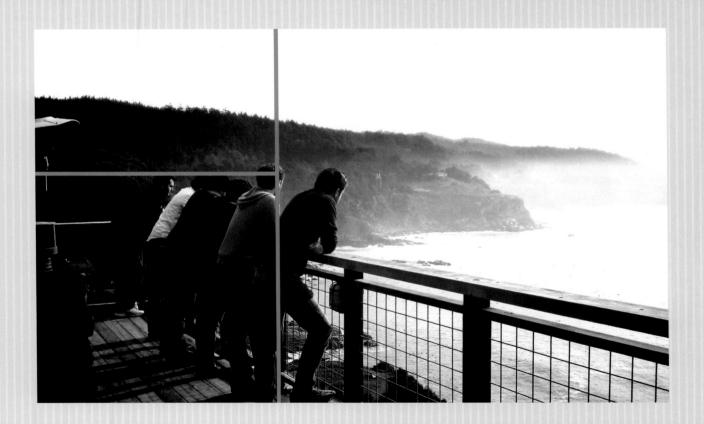

PHOTOGRAPHY BASICS

the same proportions as the original (see photo on previous page). If you divided the smaller rectangle into a square and another, even smaller rectangle, the third rectangle would also have the same proportions as the original. You could divide the rectangles into squares and smaller rectangles as many times as you liked, and the tiniest rectangle would still have a 1.618 ratio of length-to-width. The same principle can be applied to triangles constructed on the Golden Ratio. Golden triangles work much in the same way, but the compositional lines are on a diagonal, creating right triangles along the golden composition lines (see bottom photo on page 20). To create a golden triangle in your mind's eye, draw a diagonal line from one corner of the picture to the opposite corner. Then, with a line starting in either empty corner, make a right triangle whose right angle rests on the first diagonal line.

While it's more difficult to visualize the Golden Ratio, a little practice and study of a wide variety of applicable images should help. Once you see the shapes themselves as they appear in nature, in sketches, and in other people's photography, you'll begin to see how the ratio could fit into your own process.

Eventually, as you become more experienced in looking for and finding these invisible proportions, you'll start to see these and other kinds of lines emerge in all your photographs. The strong, inherent lines in your images that the eye naturally follows are called "leading lines" (see photos on following page). These lines can be drawn by architectural features, shadows, roads, horizons—almost any element of your image—and they create a sense of movement in your pictures and usually help draw attention to a focal point. When you're setting up a shot, always first take inventory of any interesting lines that might naturally exist, and be sure to incorporate them in your composition in harmonious, pleasing, and interesting ways.

Keep in mind, it's still possible to take terrible, boring photos that perfectly follow the Rule of Thirds or Golden Ratio. While the techniques of photo composition are important to creating images you can be proud of, remember to always bring your own creativity and sense of beauty to the table. Remember, the best photographers are artists first and technicians second.

HOW TO SHOOT LANDSCAPES

Ansel Adams said, "Landscape photography is the supreme test of the photographer—and often the supreme disappointment."

You can create gorgeous vistas of land and sea with your Android phone, but be warned: Straying into boring territory is far too easy in this category, especially since you don't have the luxuries of long exposures, tripods, aperture settings, or other traditional photography tools. While app-enabled editing can make up for some of these deficiencies, you should make sure you know your stuff when it comes to composition. Otherwise, that view that was so perfect in person will be rendered forgettable by your camera shutter.

When thinking about composition, remember that your landscape will include many, many subjects large and small and of varying sizes, shapes and colors. And many factors, such as lighting and distances, will be out of your immediate control.

Before you begin shooting, hold up your lens and take a full inventory of the objects in the frame. Where are the lines and curves in your landscape? What colors are present, and where is the light coming from? Where is your eye drawn? Take a few test snaps to get an idea for how your camera is capturing the scene, then optimize by changing your position or perspective to put the main object at eye- or camera-level. In some cases, this might entail a low-angle shot with your camera phone resting on the ground.

Either your foreground (in the bottom third of the frame) or your sky should have something visually fascinating in it. Without craggy rocks, otherworldly cloud formations, or something unusual and beautiful in the shot, your landscape might turn out flat and boring. Position the most interesting objects along strong compositional lines, and your landscapes will pop.

Tips for Great Landscapes

1. Make sure your camera is level with the horizon.

2. Check your white balance to ensure accurate color capturing. If your light is switching a lot, set your white balance to auto.

3. Try shooting scenes in "the golden hours" of dawn or dusk for more interesting lighting, but don't shoot when it's too dark.

4. Pick the main object your camera is going to focus on, and make sure it's correctly focused. In most apps, you can tap on the part of the image that the camera should focus on.

5. Experiment with different perspectives. Try lying on the ground or shooting from a tree.

6. Don't shoot directly into the sun. If your landscape features a gorgeous sunrise or sunset, try to position the celestial orb closer to the edges of the frame, up to about a quarter of the frame's width away from its edge. You'll get that dramatic lens flare without the colossal blow-out.

7. Experiment with different, larger aspect ratios, such as a panoramic shot.

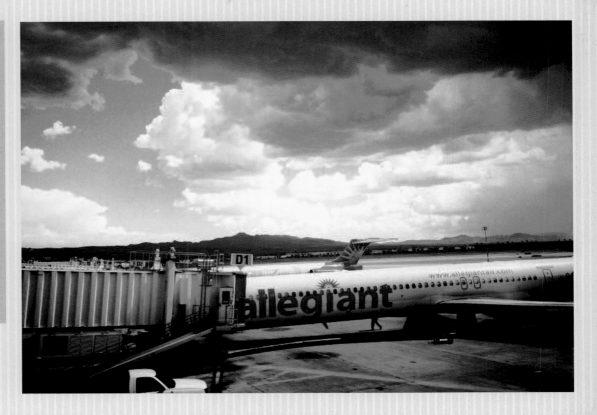

HOW TO SHOOT LANDSCAPES

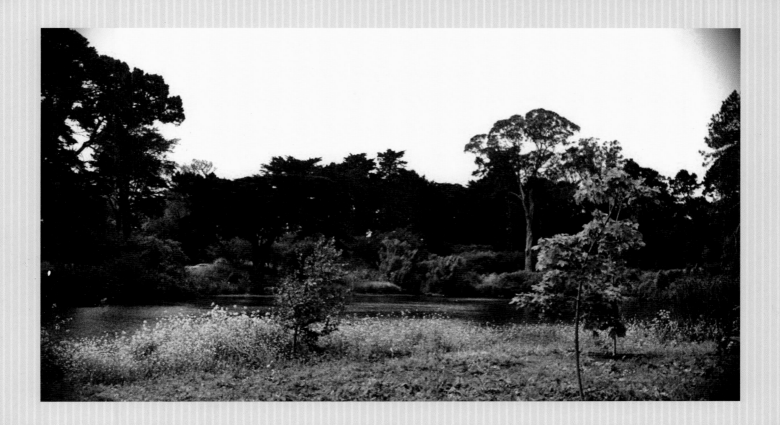

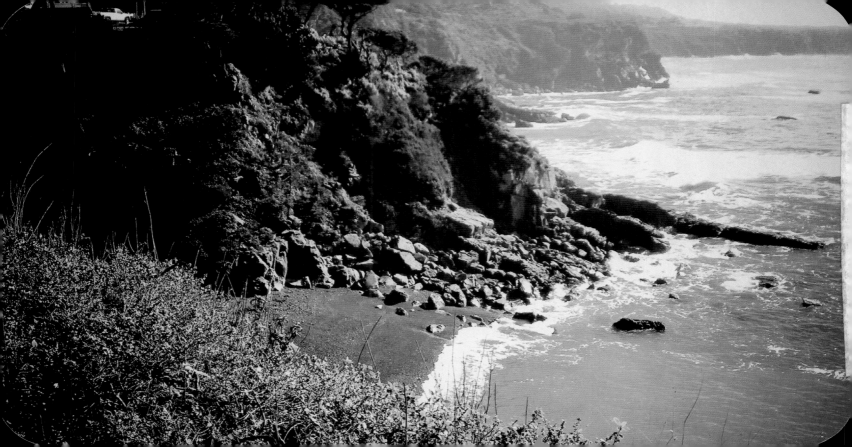

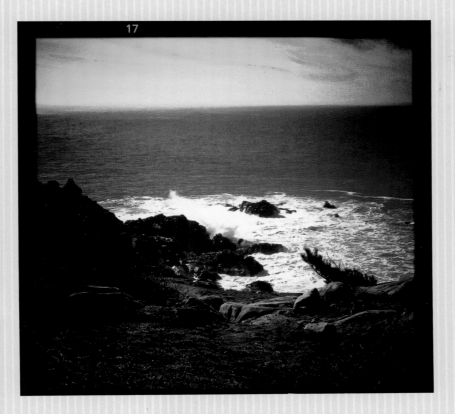

17

HOW TO SHOOT MACROS AND STILL LIFES

Some of the easiest, most interesting, and most fun photos you can take will be images of still objects. As creative people, we all are capable of seeing the beauty in everyday things; with an understanding of perspective and composition, you can share the beauty you see with the rest of the world, too.

Also, shooting still-life images is the perfect opportunity to experiment with new photo apps and settings. Color highlighting, cross-process effects, and other editing adjustments might wreak havoc on your landscapes or make your human subjects look freakish, but in a still life, your editing skills and creativity can really shine without overpowering the subject.

Get up close with whatever you're shooting—hood ornament, insect, glass bottles, your lunch, whatever. Getting your relatively underpowered camera to focus at such short range might be a bit of a strain, so check your lighting, tap to focus your camera, reposition yourself, and optimize as necessary.

Macros and still-life shots can amplify any motion in the camera, rendering photos blurred and sloppy. If your device or app has a setting that will minimize the blurry look caused by a slightly shaky grip on the device, use it! If not, take a deep, long breath, and press the shutter before you exhale, focusing on relaxing and keeping your hands as steady as possible. You can also try resting your device on a non-moving surface.

Finally, these are subjects that can be posed any way you like and that can hold a pose forever! Use that to your advantage, and don't shy away from manipulating the objects. Try a few different angles and different depths, and move your objects around to find the best lighting. Incorporate different objects in your composition, or try taking your objects into an entirely different setting—perhaps someplace incongruous and unexpected for a more dramatic photo.

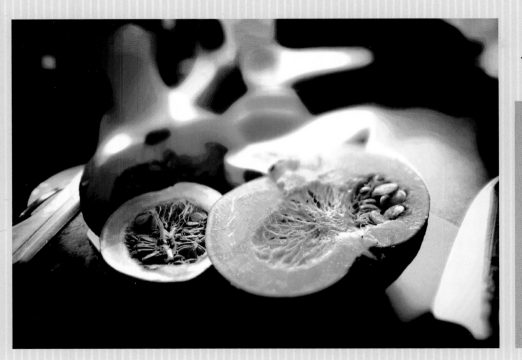

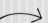

Tips for Shooting Macros and Still Lifes

1. Some devices and some apps have macro settings. Check your phone, and if a macro setting is available, use it with confidence.

2. If you're shooting something shiny, make sure your reflection isn't in the image—unless, of course, that's the effect you're going for.

3. Don't block the light with your body or your camera.

4. Try to use natural light and avoid flash, as flashing lights this close to the subject may lead to blow-out.

5. Get on eye-level with your subjects. Try low angles.

6. If your objects just won't stay in focus, it might be your app. Switch to the native camera app, and try again.

HOW TO SHOOT MACROS AND STILL LIFES

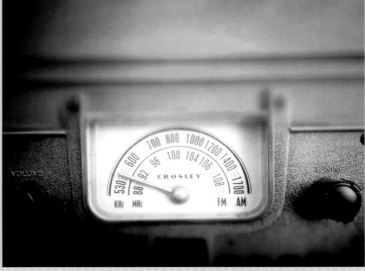

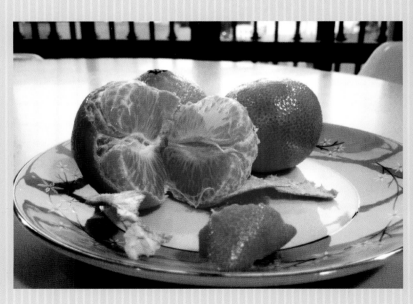
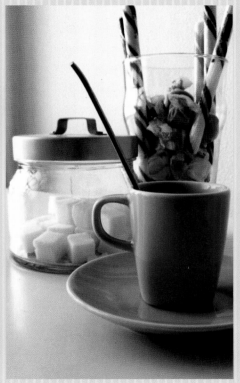

HOW TO SHOOT PEOPLE

Improvisation and spontaneity—both from you and from your subjects—is the key to great photos of people, who will typically be the trickiest subjects you'll ever try to capture.

When shooting people, long waits for the shutter click can lead to forced smiles, stiff poses, and pictures that don't represent the spirit of the moment in which they were captured. If you're taking a posed shot, have your camera and/or your camera apps ready before you tell your subjects to "say cheese."

And always shoot more than once! Many subjects means many opportunities for blinking, grimaces and other faux pas.

Lighting is also hugely important. Whenever possible, try to shoot people in natural light, with the subject's face turned toward the light source. Photos of backlit, downlit or uplit faces can reveal ugly shadows. And go easy on the flash, as it tends to blow out and flatten features, as well as create unwanted shadows in some cases.

In most cases, try to position your subject's eyes near the center of the frame. When shooting a posed shot, have your subject look at the ground, then look up only as you're ready to press the shutter button. Faces will be much more relaxed and natural with this technique. To avoid the dreaded "double-chin effect," tell your subjects to position their heads slightly farther forward than they normally would.

If you're shooting multiple subjects, try to skip massive line-up group photos with people side-hugging and leaning in the edges of the frame. For more creative and interesting compositions, play around with angles and perspectives—although you should generally stay away from low angles, which can lead to wide-looking lower bodies, double chins, awkward facial expressions, and worse.

You can stand on a chair and shoot the group from a slightly elevated perspective, get a close and tight shot of just your subjects' faces, stagger your subjects so some people are in the background and others in the

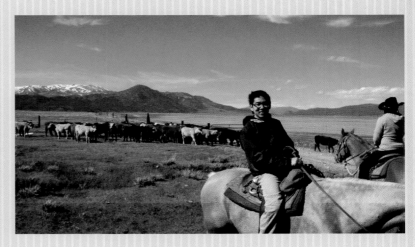

foreground, angle your camera by 25 or 30 degrees, or get really creative with poses and shoot a panorama.

However, your best bet is often the candid shot. These are more difficult to capture—prepare to take 20 snaps and discard 19—but when finished, they usually do everything a really great photo should do, summing up the moment and the people in a way that a "grip and grin" line-up never could.

To get a good candid shot, try to make yourself invisible. Stay quiet and turn off your flash; if possible, pretend you're checking your text messages or playing a game on your phone. This is one instance where it's great to be a mobile photographer rather than a traditional-camera photographer: With your tiny device rather than a huge lens in hand, you're much easier for your subjects to ignore, which can lead to much better, more natural, candid shots.

Finally, if you're using an editing app, most people look best when slightly desaturated and at lower-contrast settings. A slightly less colorful setting can help to even out skin tones, while Lomo, cross-processed, or toy camera effects can give skin a bluish tint, create hideous under-eye shadows, or throw red blotches onto an otherwise lovely face. We'll have more on editing apps in the next chapter, but try using Vignette's Portra setting, Camera Effects' Magazine setting, or any number of faded, retro-type camera settings. Black and white can also be a good option, especially for portraiture.

HOW TO SHOOT PEOPLE

Avoiding Common Mistakes: Photos of People

1. Never shoot a picture over a restaurant table of dirty dishes—it's impersonal and clichéd.

2. "Gang" signs, peace signs, bunny ears, kissy lips, finger mustaches, and other hallmarks of casual posed photography should all be avoided, unless you're going for a kitschy, photo-booth effect.

3. Think twice before photographing a person who is eating.

4. Vanity cliché warning: Never shoot a picture of yourself in a mirror, including car side mirrors. Turn the phone around, and you'll be able to see the frame in the mirror while you shoot your self-portrait.

5. Use an app that will take multiple quick exposures, so you only shoot once in case your subject blinks.

6. Always do a background check! If the photo isn't a tight crop, your background may contain unintended and distracting elements.

7. Don't over-edit. Altering color and contrast too much isn't artistic and will leave you with a photo worthy of a teenager on MySpace rather than a budding Android photographer.

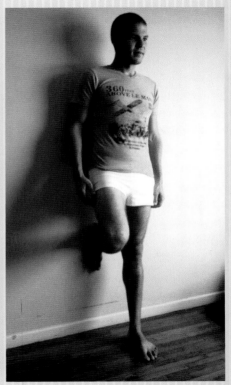

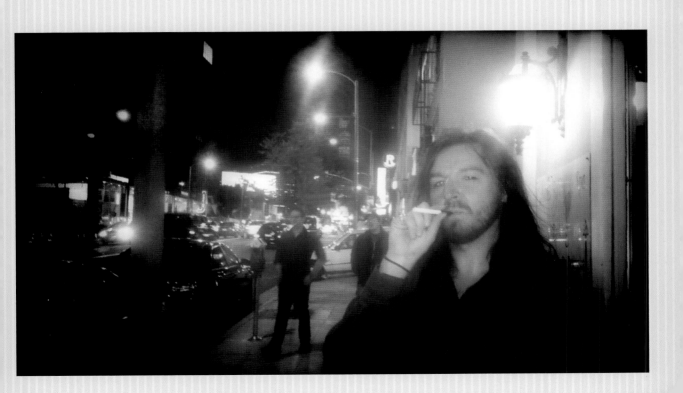

APPLICATIONS

How to Improve and Edit Your Photos With Apps

The Android Market (https://market.android.com) has an ever-expanding offering of photography apps designed to help you manage and edit your photos. Some will even help you take better photos in the first place.

We're recommending a few good apps in this section, but you might find that you only need one or two to get the job done. Give these apps a try, and also explore the photography section of the Android market for other or newer options. If a "lite" or "demo" version of an app is available, always try the free version of an app before you commit to buy. Check out all the settings and options in an app before you decide whether you love it or can live without it. And remember, even if you buy an app and end up hating it, you can get a full, no-questions-asked refund at any time within 15 minutes of your purchase.

Not every photo you take will need editing, and sometimes, edits will be as simple as cropping. Other times, you'll want to correct an overly dark exposure or fix some inaccurate colors.

But make sure that your images don't look like an extravagant parade of special effects; ideally, the photography should speak for itself. If the photo on its own isn't appealing, then learn to take better photos before going on an app-downloading binge.

That being said, if you're going for a more artistic result and want to use some of the more extreme editing effects available to you, it's generally advisable to save the surreal colors and moody lighting for still lifes and landscapes; unrealistically colored and overly contrasty photos of people can come off as bizarre and amateurish. Then again, like most rules, this one can occasionally be broken; just tread carefully, Picasso!

The Android market has an ever-expanding offering of photography apps to help you manage and edit your photos.

VIGNETTE

Not to be confused with a classic photography term that denotes diminished brightness at the perifery of an image, Vignette is the granddaddy of all Android photography apps. Although it's one of the more expensive photo apps in the Android Market (you can try the free demo first, if you like), it's easily the most versatile in its class and will help you create photos that are subtle, striking, and truly one-of-a-kind. If we could pick one app that was guaranteed to cause Android envy in any mobile photographer, Vignette would be it.

In addition to the wide variety of settings, Vignette won't resize your photos unless you tell it to. This means that if you've got an 8MP camera in your Android phone, your images are going to be large and crystal clear, which isn't always a guarantee with photo-editing apps. In fact, because of this distinction, if you want to print out hard copies of your images later, Vignette is the only app we'd recommend using.

Best of all, in addition to shooting directly from within the app, you can import images you've already taken with your native camera or another app for special editing in Vignette. This is particularly handy when you want to capture a fleeting moment quickly and don't want to wait for the app to load.

For this application, we recommend trying out all its settings in various scenarios and different lighting situations. In combination, there are hundreds of ways to take a picture with Vignette. You'll be able to preview each new setting before you choose to save or share the image in question.

You can also choose specific camera and file format settings from the viewfinder screen; this will help you get the most out of your images. Once you get a feel for Vignette, check out its many shooting options and try filmstrips or double exposures.

1 Shoot an image from within the app. You can also choose "Import" from the menu to edit a photo you've already taken using the native camera or another app.

2 From the menu, choose an effect category and specific effect. You can navigate back and forth, experimenting to find the best settings for your image.

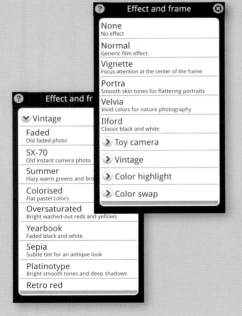

Effect and fr

⌄ Vintage

Faded
Old faded photo

SX-70
Old instant camera photo

Summer
Hazy warm greens and bro

Colorised
Flat pastel colors

Oversaturated
Bright washed-out reds and yellows

Yearbook
Faded black and white

Sepia
Subtle tint for an antique look

Platinotype
Bright smooth tones and deep shadows

Retro red

Effect and frame

None
No effect

Normal
Generic film effect

Vignette
Focus attention at the center of the frame

Portra
Smooth skin tones for flattering portraits

Velvia
Vivid colors for nature photography

Ilford
Classic black and white

› Toy camera

› Vintage

› Color highlight

› Color swap

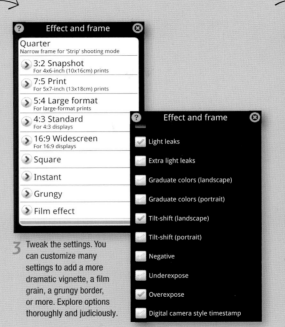

Effect and frame

Quarter
Narrow frame for 'Strip' shooting mode

› 3:2 Snapshot
For 4x6-inch (10x16cm) prints

› 7:5 Print
For 5x7-inch (13x18cm) prints

› 5:4 Large format
For large-format prints

› 4:3 Standard
For 4:3 displays

› 16:9 Widescreen
For 16:9 displays

› Square

› Instant

› Grungy

› Film effect

Effect and frame

☑ Light leaks

☐ Extra light leaks

☐ Graduate colors (landscape)

☐ Graduate colors (portrait)

☑ Tilt-shift (landscape)

☐ Tilt-shift (portrait)

☐ Negative

☐ Underexpose

☑ Overexpose

☐ Digital camera style timestamp

3 Tweak the settings. You can customize many settings to add a more dramatic vignette, a film grain, a grungy border, or more. Explore options thoroughly and judiciously.

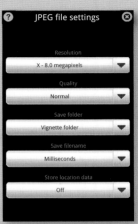

JPEG file settings

Resolution
X - 8.0 megapixels

Quality
Normal

Save folder
Vignette folder

Save filename
Milliseconds

Store location data
Off

4 Save and share your images from the app or from your phone's gallery.

PHOTO EFFECTS

Photo Effects is a robust app that will give you great web-quality photos. It allows you to edit photos you've taken with your native camera or another photo-taking app, and the settings put Photo Effects on par with other top mobile apps. You can see thumbnail previews of all the effects before you decide on an option, and sharing is seamlessly built into the app.

One of the best things about this app is that it allows you to layer effects. You can also use a built-in slider to tone down or intensify an effect. Overall, this app gives its users much more control than other Android Market offerings.

One major downside of the app is that it automatically downsizes photos to an 800 pixel maximum height or width. This spells bad news if you want to print out your images or use large, high-quality photos on the web. However, for most uses, including Facebook sharing, an 800 pixel-wide photo is perfectly fine.

One quick note about your finished photos: They won't appear in their own folder once they've been saved; instead, look for them in the "all photos" or "camera photos" section of your phone's gallery.

Connect Online

Photo Effects—http://www.softpedia.com

1 Upload an image from your gallery.

2 Choose an effect to start with; you can make adjustments later.

3 Tweak the photo by adding or removing effects, frames, and other layers.

4 Export your photo to your preferred photo-sharing site; the photo will save automatically.

FXCAMERA

FxCamera is an interesting photo app for shooting cool snaps with dramatic or retro effects. The app has a small range of meta-settings that can each by adjusted and fine-tuned to create more customized effects and unique images. Be sure to choose the settings that will give you the largest, highest-quality images possible.

As a free app, FxCamera gives fewer options than some of the more robust paid apps; however, in general, its settings are absolutely adequate for point-and-click shooting when you're going for a retro look and feel. On that note, its retro settings are the ones we primarily recommend. ToyCam and Polandroid are two emulators with multiple settings that allow for decent, quick snaps. Other effects, such as the fisheye and mirror "lenses," can lead to hokey photos and cheesy effects.

Unfortunately, the app doesn't allow for previews or changing the settings on a photo after it's been taken, and it also won't let you modify photos from your gallery, so be prepared to love what you snap when you snap it.

Connect Online

FXCamera—http://www.appbrain.com
Image Gallery on Flickr—http://www.flickr.com/groups/1203688@N20/

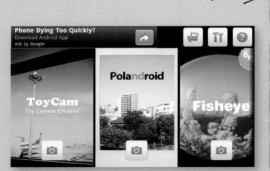

1 Choose the primary camera setting you want to use.

2 Configure the camera according to your preferences, including image size and quality.

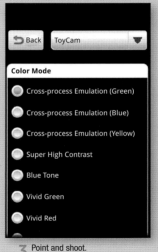

3 Point and shoot.

4 Share images from your phone's gallery.

CAMERA360 ULTIMATE

This app's free version, Camera360, can be found in the Android Market, where it's garnered a 4.5-star rating and more than 250,000 downloads. From within the free app, you can download the paid version, which brings more effects and fine-tuning options.

Camera360 Ultimate brings a few elegant and welcome touches to the mobile photographer. In general, the range of options in this app is narrower, but the settings afford more subtlety and control. For example, you can select from nine different settings in the "Lomo" category.

Aside from its special-effects filters, it gives users a more elegant tilt-shift option and a small selection of compositional guidelines in the viewfinder. It seems to handle flash exposures particularly well, showing detail without too much blowout; and it's got a good setting for shooting nighttime scenes without losing too much detail. It's also got great anti-vibration settings for shaky hands, and it can shoot at huge sizes, perfect for those who wish to print their snaps.

Connect Online

Camera360 Ultimate—http://www.pinguo.us/ and https://market.android.com/
Twitter—Camera360_blog

Select your favorite photography mode.

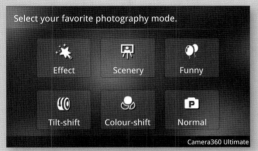

Effect Scenery Funny

Tilt-shift Colour-shift Normal

Camera360 Ultimate

3 Shoot your image.

2 If you want to tinker with ISO, light metering, JPEG quality or other settings, tap your phone's menu button.

1 Select a general photography mode, then adjust the settings for that mode.

Select your favorite effect.

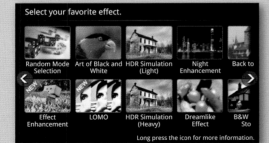

Random Mode Selection Art of Black and White HDR Simulation (Light) Night Enhancement Back to

Effect Enhancement LOMO HDR Simulation (Heavy) Dreamlike Effect B&W Sto

Long press the icon for more information.

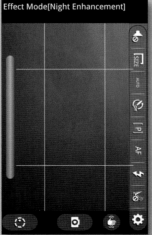

Effect Mode[Night Enhancement]

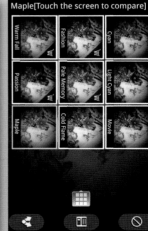

Maple[Touch the screen to compare]

Warm Fall Fashion Cyan

Passion Pale Memory Light Cyan

Maple Cold Flame Movie

4 Once you've captured your image, you can press and hold the screen to see a quick before-and-after comparison of your chosen effects. Depending on the settings, you might also have the option to do some in-app editing of the image.

5 Save, discard or share your photo, either from within the app or from the gallery.

RETRO CAMERA PLUS

If you want to take pictures that mimic the look and feel of classic film cameras, this point-and-click camera simulator is the app for you. Retro Camera Plus mimics such iconic devices as the Soviet Lomo, the oft-imitated Polaroid, and even homebrewed pinhole cameras. You won't get to fiddle around with custom adjustments for color and contrast, but you can still get both subtle and dramatic pictures out of your camera phone. You'll also have plenty of options for both color and black-and-white shooting.

Before you get started, you'll want to tinker around in the settings to get higher-resolution images, adjust the flash use, nix the branded frames around your images, and turn off the decidedly old-school whirring of the shutter sound effect. Also, tour the "about this camera" section for each of the available Retro Camera Plus settings; you'll learn about each camera's unique settings and effects.

A couple caveats: You'll want to make sure you've got good lighting and a great image on the other end of your viewfinder—which itself is too tiny to show what the finished photo will actually look like. And you won't get a preview of your image before the lengthy "processing" phase begins. As a result, using this app is almost as challenging and unpredictable as using a film camera, and the results can range from moody to muddy if you're not careful. Also, you can only take pictures from within the app; you can't upload them from your gallery. We recommend you try the free version of this app before downloading the paid Plus version, and as with many other tools in life, practice eventually makes perfect.

Connect Online

Retro Camera Plus—http://www.urbian.biz/apps.html
Image Gallery on Flickr—http://www.flickr.com/groups/1456124@N22/

1 Choose a camera to take your image.

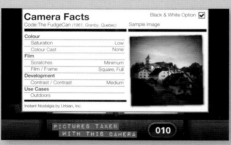

2 Point and click—no adjustments necessary or available.

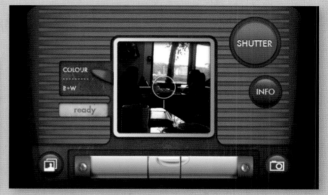

3 Wait for the image to develop, then check it out in the app's gallery or in your phone's native gallery. You can share images from either location.

CAMERA ZOOM FX

This application's effects can seem heavy-handed next to those of other apps, but it still has its upsides for the amateur mobile photographer. You have the option to shoot in normal mode and layer effects afterward, as well.

In this app, you can control features such as stable shot, white balance, burst mode, and much more. It also gives you a good variety of onscreen compositional guides, including a very handy horizon mode that shows you whether you're holding your camera parallel to the horizon. In a word, if you really delve into the settings, you can get some great photos out of Camera ZOOM FX.

In addition to its native features, the app has a ton of free add-on packages available, including borders and texture layers, in the Android Market. You can see them when you search for "Camera ZOOM FX." They run the gamut from silly to functional, and they're all free.

Keep in mind that you won't be able to preview images, change the primary settings on a photo you've already taken, or edit an image from your gallery.

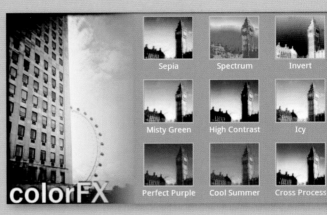

1 Select primary shooting mode, "buddy" package, and other options.

Connect Online

Camera Zoom FX—http://www.androidslide.com/
Image Gallery on Flickr—http://www.flickr.com/photos/51907529@N02/
Twitter—androidslide

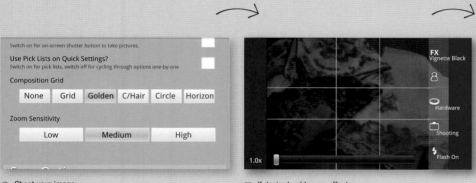

Switch on for on-screen shutter button to take pictures.

Use Pick Lists on Quick Settings?
Switch on for pick lists, switch off for cycling through options one-by-one

Composition Grid

| None | Grid | Golden | C/Hair | Circle | Horizon |

Zoom Sensitivity

| Low | Medium | High |

FX
Vignette Black

Hardware

Shooting

Flash On

1.0x

| Save | Delete | Add FX | Share | Upload |

2 Shoot your image.

3 If desired, add more effects.

4 Share, save, upload, or delete
your photo.

APPLICATIONS

ADOBE PHOTOSHOP EXPRESS

Some mention should be made of Adobe's entry into the mobile photo-editing world. The makers of Photoshop have brought this free, lightweight tool to the Android Market. It's good for simple crops, brightness and saturation adjustments, and a handful of very basic effects.

 If the photos you're taking are already good and need only slight tweaks, Photoshop Express is a good app to have on hand. But you won't get the artsy, dramatic, or custom-looking effects you'll see from other apps. This application is less fun, more functional. We do like being able to edit pics after the fact and being able to undo and redo effects at will. The previews of effects and sliding scale of effect intensity is also a nice touch.

Connect Online

Adobe Photoshop Express—http://mobile.photoshop.com/
Twitter—photoshopdotcom

1 Load an image from your gallery.

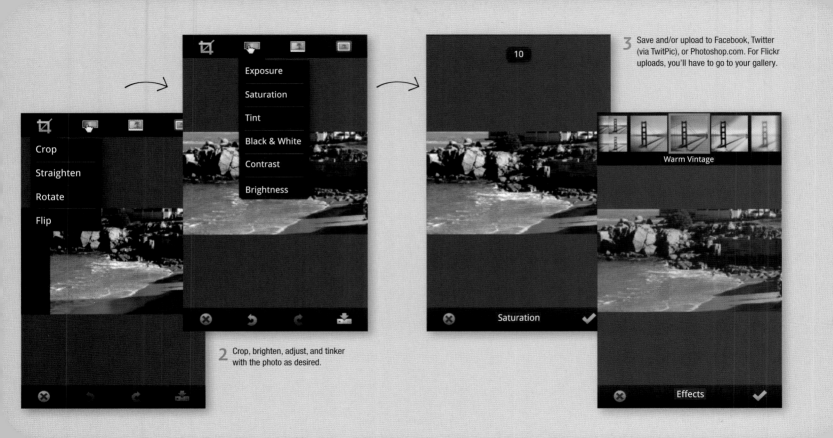

Crop
Straighten
Rotate
Flip

Exposure
Saturation
Tint
Black & White
Contrast
Brightness

2 Crop, brighten, adjust, and tinker with the photo as desired.

10

Saturation

Warm Vintage

Effects

3 Save and/or upload to Facebook, Twitter (via TwitPic), or Photoshop.com. For Flickr uploads, you'll have to go to your gallery.

OTHER APPS TO TRY FOR SPECIALTY EFFECTS

Action Snap

If you'd like to take multiple exposures and compile them into a single shot, try Action Snap, a free app that lets you shoot four photos back-to-back at custom intervals. You can add a Lomo or sepia filter, and the images can be displayed in a row or in a 2×2 grid.

Action Snap—http://www.oursky.com/action-snap/

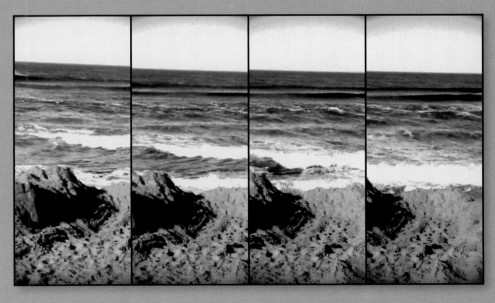

Photo Wonder

Has a random forehead zit or a surprise arm bulge ruined an otherwise excellent photo? If you want to do some light retouching to save a friend's ego—or your own—try Photo Wonder, a free app that will let you selectively nudge, pinch, and blur your way into slightly enhanced portraiture. But use a light hand, and make sure images stay believable. The best portraits are the result of good lighting and good angles, not post-production editing.

Photo Wonder—http://jingling.cn/index_en.htm

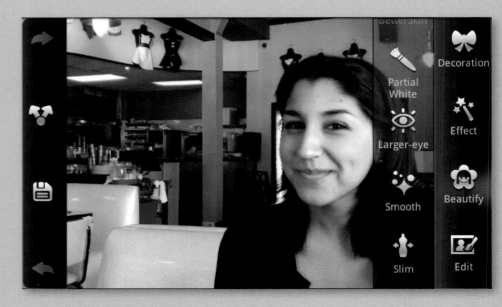

OTHER APPS TO TRY FOR SPECIALTY EFFECTS

Photaf 3D Panorama
For panoramic stitching download Photaf, a free app that's upgradable to a paid app if you want high-res panoramas. The quality of the end result is excellent in this app; you won't see a ton of light and color variation from section to section in your panorama. For a little extra fun, try this app for group photos.

Photaf 3D Panorama—http://www.photaf.com/

ToonPAINT

For a graphic novel effect, check out ToonPAINT a $1.99 app that lets you turn snaps of people into comic book-like drawings of people, places and things. The app itself renders a line drawing, which you can then "ink" yourself by using your dextrous fingers, a variable-size brush, and a pinch-to-zoom feature. The pictures you create with ToonPAINT can be very cool, but the results are definitely hit-or-miss.

ToonPAINT—http://toonpaint.toon-fx.com/android/

CHAPTER 4

SHARING YOUR PHOTOGRAPHY

Once you've got the hardware, software, and compositional chops to create gorgeous mobile photography, you're going to want to start showing your snaps to the wider world. More often than not, you'll want to post your photos to the Internet.

Some of the most popular services on the web, including Facebook, Flickr, WordPress, Tumblr, and more, are custom-made for photo sharing and have special tools for allowing you to upload your images directly from your mobile and display and tag them in an optimal way.

In this chapter, we'll look at the details of these services, including which licenses, themes, and privacy options are best for you.

A NOTE ON PRIVACY

The very first factor to take into consideration is whether you want your pics to be visible to the entire Internet-using population. On almost every image-sharing website, including social networks and photo-specific sites, you will have options to selectively limit who can see your photos. Use these features judiciously, especially when posting photos of friends, family, identifiable locations, and any events involving alcohol or other questionable substances.

Posting an image

When posting an image, ask yourself the following four questions:
1. How does this image reflect on me?
2. Could a stranger pinpoint where I live and work based on this image?
3. Does this picture incriminate—even in the mildest sense—any of the people in it?
4. Would I want a potential employer or a potential romantic interest to see this photo?

If your picture passes the test, feel free to post anywhere and as publicly as you like. If not, you might want to share it just with friends, upload it privately so only you can view it, or in the most sensitive of cases, not share it online at all.

…you will have options to selectively limit who can see your photos.

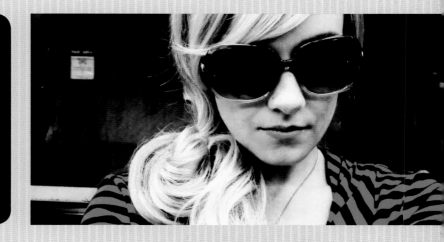

COPYRIGHT OR CREATIVE COMMONS?

Another question to ponder before your post is whether or not you want others to be able to repost or reuse your photo. There are both advantages and pitfalls in sharing your photos. You need to decide what works best for you and your specific images.

Creative Commons is a licensing system that lets you specify how and where your photos can be shared. Sharing your images can often yield good things—more people get to enjoy your art and interact with you when you share. Many sites, including Flickr, currently support Creative Commons licensing.

Many kinds of Creative Commons licenses exist. For example, with a general CC license, you're basically giving anyone the freedom to reuse and remix your image. If you choose a CC-Share Alike license, you'll share with others as long as they share, too. For CC-Attribution licenses, you ask others who use your image to attribute, or credit, you wherever the image is used. And a CC-Non Commercial license means that corporate or moneymaking entities won't be able to use your images for their own profit.

Do some research on Creative Commons; the licenses available are very often helpful for newer or amateur photographers, as they allow your work to have maximum exposure if that is what you want. However, you may not always have as much control as you would want over how your images are used.

On Flickr in particular, using different Creative Commons licenses for different images is quite simple and allows you flexibility. For example, you may not want to post an image of your young niece, but you might want to share (with attribution) a beautiful landscape picture you took. Flickr will let you set photo licenses individually, or you can change licenses in bulk—for example, you can set the default for your images to CC-Attribution, but you can change the

license for a group of wedding photos to "all rights reserved" with just a few clicks. Always use care and weigh the possibilities, because even if you "officially" reserve photo rights, unscrupulous folks may ignore licensing and use your pictures anyway. Then it is up to you to pursue them.

If you don't want to share your images freely, you can always choose to retain all the rights to your photos. By default, you hold the copyright to any photos you publish to the web—that includes Facebook photos and any other images where a Creative Commons license is not specified. But having your copyright and defending it if someone misuses your photos are two separate issues. If you absolutely want to take no chances that a valued image might be stolen or exploited, the safest course is not to put it online.

However, if someone uses your photo without permission in a way that you don't like, you can have it removed from that person's website quite expeditiously. First, try sending a polite note stating that you don't want your image used. If your initial email or message isn't met with a prompt and favorable action, you can send the web service hosting the image a takedown notice through the Digital Millennium Copyright Act (DMCA).

According to federal law, the web service or website hosting company is required to remove the copyrighted content. If a DMCA takedown notice is required, do some research on the web, and also search the hosting site itself. For example, if your image appears without your permission on a WordPress-hosted blog, you can search Google for "WordPress DMCA," then use those links to contact WordPress customer support and have the image removed.

By default, you hold the copyright to any photos you publish to the web...but having your copyright and defending it if someone misuses your photo are two separate issues.

TWITTER

Twitter

One popular venue for socially sharing mobile photography is Twitter. This service can connect you not only to friends but also to valuable and inspiring resources, such as photography blogs, other amateur photogs, and even professional shutterbugs. By building a decent network of contacts and friends on Twitter, you can get instant feedback and even helpful advice and techniques when posting your images to the service.

This service was once primarily text-based, but it's become more image-friendly over time. For example, on Twitter.com, the web service shows images in-line with other text-based content, so when you tweet a photo to your followers, they'll be able to see a preview of it without having to go to a separate website.

Twitter is the most appropriate place to share quick snaps with a humorous or interesting focal point.

It's also good for sharing what could be called "citizen journalism," images that have a strong relation to current events. The rule of thumb for sharing your pics on Twitter is as follows: Don't self promote; do add value. In other words, if you're showing off a pretty picture just because it's pretty and you're proud that you took it, think twice before pressing the "send" button. Is this something all your followers want and need to see? Remember, you have lots of other options for showcasing beautiful photography; a tiny preview broadcast to everyone who follows you might not be the ideal option. However, if your picture is timely, informative, interesting, or will somehow add value to another person's day, share away! Just make sure the tweet itself, which acts as a caption, is as thorough and descriptive as possible within Twitter's 140-character limit for messages.

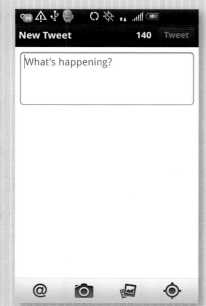

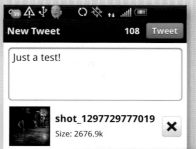

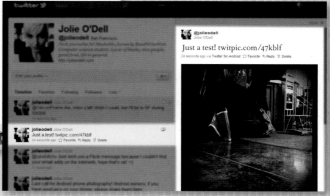

TWITTER

If you've downloaded the official Twitter Android app, you'll notice that you have the option to tweet and upload images. Touch the icon to create a new tweet; you'll see a photo/video icon at the bottom of that screen. Once you click that icon, you'll be able to go through your galleries to pick one image to upload to Twitter.

Your tweet is then uploaded, and from the Twitter.com website, your image will be viewable in line with your tweet. How the image gets attached to your tweet is at least partially up to you. From your settings menu in the Twitter app, you can choose either Twitpic or Yfrog as your photo uploading service.

The granddaddy of Twitter-based pic-sharing is TwitPic. This service integrates conveniently and completely with Twitter, and it allows you to group and tag your photos in interesting and useful ways. You can tag your friends, including other Twitter users, in your pictures; and you can geotag your images through Twitpic's support for Twitter Places. Also, you can group your photos by event—for example, a birthday party, a day at the zoo, or any other particularly photo-friendly happening. Twitpic also allows for Twitter-enabled commenting. Any comments on your image will also be shown on Twitter as replies to your tweet.

Twitgoo is another Twitter-based image-sharing service. All of the major Twitter pic-sharing services will let you sign up and sign in with your current Twitter account. Which service you use is entirely a matter of personal choice and which features you need and use. It's important to note that Twitpic and Yfrog also support video uploading; we'll talk more about shooting and sharing video from your mobile later in this book.

FACEBOOK

For sharing images of people, especially family and close friends, Facebook is without doubt the best choice for almost every occasion. Facebook was one of the first web services to allow tagging, or labeling people in an image in a way that would increase awareness and use of the image across many different parts of the site. When you post an image to Facebook and tag someone in the image, that photo will appear on your Facebook Wall, on the other person's Wall, in your photo album, and in the other person's photos. Additionally, people will be able to comment on your image, creating more visibility on their own walls.

To get images from your phone to your Facebook profile, simply download the official Facebook app from the Android Market. You can choose to shoot pics directly from the app, or you can upload images taken with other apps. When you upload the image, be sure to include a descriptive caption, and go to Facebook.com afterward to tag your friends in the pictures you've taken.

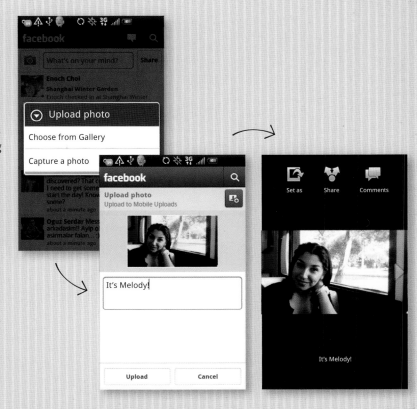

PRIVACY, COPYRIGHT, AND ETIQUETTE

Recently, Facebook changed its photo-viewing interface to make viewing images more pleasant and convenient. The site now also allows its users to download high-resolution images directly from Facebook.com—however, this doesn't mean that Facebook "owns" your photos or that anyone has your permission to use downloaded photos from Facebook.com.

One important part of Facebook photo-sharing is understanding privacy and image ownership. According to Facebook's terms of service, you do own and hold copyright for all the images you post to Facebook; in posting them, you simply give the service permission to use the images on the website and in some Facebook applications. If you delete a photo from your Facebook account, you revoke Facebook's right to use it.

Most importantly, make sure you understand your own Facebook privacy settings; you can choose who gets to see your images, and you have a very specific set of controls for image sharing. For example, you can choose to only let your friends see images you're tagged in; you can create a folder of images, such as "Mobile Uploads," that is visible to everyone on Facebook; you can create a separate folder for a friend's birthday that is visible to you, your friends, and all the friends of your friends. With such a granular level of control, you owe it to yourself to thoroughly explore privacy and sharing options and to understand where your images are posted before you share them.

With regard to tagging people in your images, always try to tag each person in a given set of images at least once so that he or she can go through the rest of the set and tag him- or herself. If you have images of people you don't know, try to tag that person's friends, who in turn will tag anyone you're not personally connected to on Facebook… yet.

As a matter of good manners, don't tag people in images in which they do not appear; it's annoying to your friends, and it creates a confusing mess on your friends' Facebook Walls and profiles.

If someone untags himself in an image you took; don't take it too personally. The decision to untag oneself can be made for myriad reasons, ranging from vanity to privacy to subterfuge. The only time you need to take action is if someone contacts you and asks you to remove an image—in which case you should do so immediately and without asking personal questions. If the image contains other people who don't mind being in your Facebook photo, you can choose to crop the offended party out of the picture, if possible. However, it's usually far less hassle and far more civilized to respect the privacy and wishes of your photographic subjects when it comes to Facebook sharing.

Finally, I'll share an unspoken rule of Facebook (and indeed, general Internet) etiquette: If you take an unflattering image of someone, don't upload the image. If the picture has some comedic value, and if you're absolutely sure the featured person won't mind, this rule can be bent a little bit. But in most cases, it's unkind to exhibit the less photogenic aspects of your friends and acquaintances. If you need to crop out a person with an untimely squint or blink, feel free to do so; if you just need to take a better picture, again, do so. But don't make your friends look bad by uploading unfortunate pictures of them.

LOCATION-BASED SHARING

The budding shutterbug never shines as brightly as when he is on the road. From the mountains to the prairies, the joys of travel are particularly well-aligned with the practice of mobile photography, and the advent of location-based services is a boon to the traveling mobile photographer.

In addition to far-flung adventures, local exploration can be a lot more fun with location-tagged photos. Location-based photo-sharing services simply share your photo with location information attached. "Location information" can be as general as a neighborhood or as specific as a venue name or even longitude and latitude coordinates. "Why would I want anyone to know where I took a picture?" you may ask yourself. Doesn't that rather negate the concept of online privacy?

While it may be foolhardy to publicly share an image and location information for a picture of your child taken inside your own home, for example, it might not be a bad idea to attach similar location data to an image taken at a local restaurant or public park. In the latter examples, you're not so much revealing personally identifiable information as you are adding to the public body of knowledge about public places and things.

The Android Market is full of applications to help you safely share location information. Foursquare is one of the more popular location-based services; it allows you to "check in" at venues and upload relevant photos and tips about those places. Your images will appear in a location's Foursquare listing for all other users to see. Gowalla is another check-in application that lets you include a photograph along with your check-in. Yelp's Android app offers a very similar feature for uploading images in connection to check-ins and customer reviews of restaurants, cafes, bars, and other venues.

PICPLZ

But for apps that put images first, take a look at Picplz, a free service that's been making a splash in the Android Market fairly recently. It offers an easy-to-use, all-in-one package for photo editing, location data, and social sharing. You can follow and be followed by other Picplz users, and the app also integrates with Facebook and Twitter for convenient sharing across those networks, too.

To use Picplz, download the app from the Market, sign up, snap a pic, choose a setting or filter, pick (or abstain from including) your location, decide whether and where you want to share the image on the web, then post it to Picplz. When sharing from Picplz, you can choose to have the service cross-post your image, location, and caption to a long list of services, including Twitter, Facebook, Foursquare, Flickr, and Tumblr.

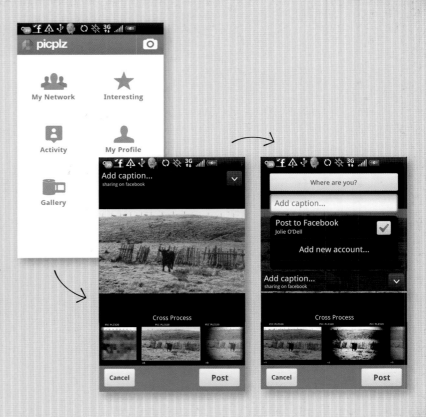

FOODSPOTTING LITE

If you're a foodie, another cool location-integrating service to try is Foodspotting. This useful little app focuses on showing you and people in your general vicinity what specific dishes are good at various restaurants. The idea is that even a mediocre dining establishment will have one must-try item on the menu. Since everyone loves to snap an artsy shot of a well-dressed plate or a perfectly presented beverage, Foodspotting is a great choice for sharing your out-and-about pics in the food and drink category.

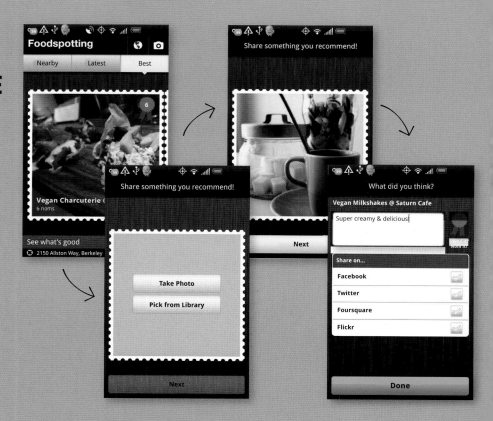

SERIOUS & GENERAL PHOTO SHARING

General Location-Sharing Tips

Other services, including Facebook, Twitter, and Flickr, have options for including location information—just remember to think twice before deciding to include location data with your image. Does the location data enhance either the understanding of the image or of the location, or is location data relatively superfluous? Is the location a private club or residence or a public venue? Does the image include people who don't use location-based services or who prefer a higher level of online privacy? When in doubt on any of these points, it might be best to forgo including location data with your photo.

One hard-and-fast rule of location-sharing etiquette must always be observed: Respect your friends' and family's privacy. Never post location-tagged photos from someone else's home, school, or place of employment unless you have explicit permission to do so.

Serious Photo Sharing

For the amateur photographer who wants to share mobile snaps of landscapes, still lifes, and serious portraiture, there's another class of sites and services dedicated to offering the biggest, best, and fullest experience for sharing images.

These sites may have some integration with your social networks, allowing you to conveniently post your pics to Facebook or Twitter simultaneously; and they very often allow for the inclusion of device and location information. But the main focus here is storing larger image files and displaying pictures in an accessible and aesthetically pleasing way.

Flickr is likely the most widely-used of all these services. It allows you to store your images online in an easy-to-navigate stream, then view or download them later at several different sizes, from a small thumbnail size to the original resolution of the photograph itself. You can set your images to be private, to be viewable only be certain groups

SERIOUS & GENERAL PHOTO SHARING

(people you designate as friends, family, or both), or publicly viewable by any Internet user. Also, you can sort your pictures into easy-to-explore sets and collections—a great tool for keeping your mobile and traditional photography separate, for grouping photos by event or by meaning, and more.

Flickr doesn't yet have an official app in the Android Market; however, several substitutions do exist. While you can choose Pto pay for a Flickr uploading app, I personally recommend free apps such as FlickrFree, AndroidFlickr, and Flickr from Appsgeyser. Try a couple of these out; while they're not the most full-featured mobile applications, they will get your images, titles, descriptions, and tags onto Flickr from your phone. You can always edit image info on the service's website after the fact.

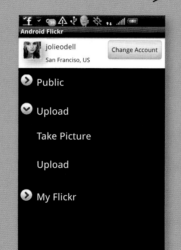

PHOTO BLOGGING

If you'd like another, more linear way to share and tell stories about your photos, you can very easily set up a photo blog. In most cases, this is free and not too time-consuming, and it allows you to set the stage for the images you present, both visually and in a literary sense. Photo blogs allow you to share details that go beyond what's in the caption—things like what else you were doing that day, what inspired you about the picture or the scene, what techniques you used, what applications and specific settings you used, and more. In some cases, the image can become incidental to the blog post—just another way of fully expressing your thoughts. A photo blog is a great choice for the multi-disciplinary creative.

Two platforms currently stand out as great choices for the new photo blogger: WordPress and Tumblr. Each platform has its official and photo-friendly app on the Android Market, and which service you choose is a matter of personal preference. Set up your photo blog from the service's website; download the Android app that corresponds to it; and get snapping!

…just another way of fully expressing your thoughts. A photo blog is a great choice for the multi-disciplinary creative.

WORDPRESS

WordPress is one of the most popular blogging platforms in the world, and their Android app just keeps getting better. You can capture images from within the WordPress app and upload them to your blog for all the world to see. Of course, you can also upload your fine-tuned photos edited in other apps, as well.

In addition to photo publishing, WordPress also supports video—uploading videos you've already shot and recording as well as uploading video directly from the WordPress app.

Best of all, WordPress blogs are free to start and maintain. To get started, go to WordPress.com and set up an account. Then, download the free WordPress app from the Android Market. From here, you'll be able to snap and upload pictures, create new posts, manage your comments and more; the WordPress mobile experience allows you to create and update a very high-quality, photo-focused website even when you're on the go.

Once you're logged in to the WordPress Android app, go to your blog's dashboard. From there, select "Posts," and click the plus icon in the bottom left corner to create a new post. Enter any text you wish to include, such as a title or post tags; then, click on the "Media" button. From there, you can take photos and videos without leaving the WordPress app, or you can upload images and video clips already in your phone's gallery. You can choose to upload one image or several.

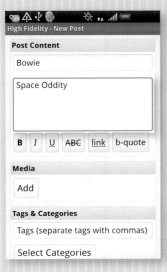

Like a lot of blogging software, WordPress comes in many different styles and flavors, some of which are beautifully suited to the showcasing of mobile (and other) photography. Think of these themes as digital portfolios for your mobile art. To change your WordPress.com blog theme, go to your dashboard and click "Appearances" on the left-side menu. There, you'll see "Themes" as an option. You can preview any theme before you activate it, and you can change themes any time without losing any posts. Search for theme names in WordPress.com's free themes directory.

DUOTONE

Duotone is a free WordPress theme specifically designed for displaying photography. Your images will be placed front-and-center, one image per page for minimal distraction.

But the real magic of the Duotone theme happens as you upload several images with several different main colors. As the viewer browses through your collection, the theme automatically detects each picture's individual color palette and changes the background to complement each photo.

In the Appearances menu under "Theme Options," you can change the main background color to one that best suits your style. Generally, bright white, very dark gray, or black work well and allow your photos to draw attention to themselves.

Monotone is a similar theme; the main difference is that it uses a single coordinating color rather than two.

As the viewer browses through your collection, the theme automatically detects each picture's individual color palette and changes the background to complement each photo.

MODULARITY LITE

Modularity Lite is a rather sparse theme perfect for photo blogging. In addition to its dark backgrounds that perfectly showcase your images, this theme offers some customization options. Under the "Theme Options" menu, you can choose to add a welcome message about your photo blog; you can also choose to include a slideshow, which will transition through a selection of full-width photos from your most recent image uploads on the home page.

If you want to go the self-hosted route, there's a veritable universe of free and paid themes for photo blogging; but unless you're quite comfortable with setting up and hosting your own installation of WordPress' open-source CMS software, you might want to either have a pro set up your WordPress blog for you or simply stick to the WordPress.com version.

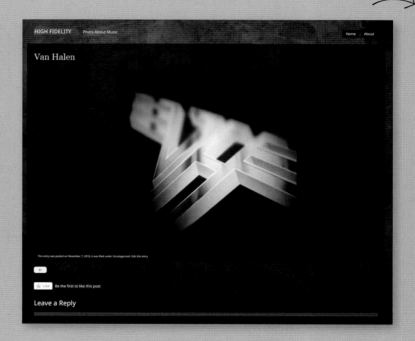

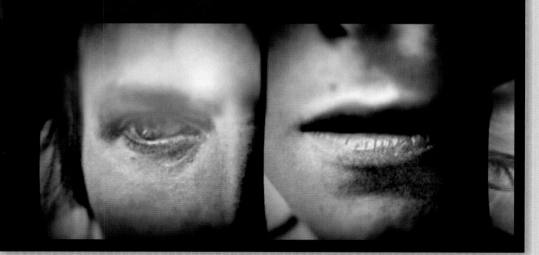

Welcome to High Fidelity

This is a photo blog about music. It features pictures of musicians, records, album art, musical instruments, and more.

Modularity Lites's dark backgrounds will showcase your images perfectly.

TUMBLR

When using the Tumblr app for Android, log into your Tumblr account, click the "Post" tab, and start entering information about the photo you want to upload to your blog. If you have more than one Tumblr blog, make sure you're posting to the correct one. You can add tags, write a caption, and include a separate URL if you wish. The post can be saved as a draft, added to your queue of posts to be published automatically at a later date, or published immediately.

As for how images get from your phone to your Tumblr, you can take images from within the app, upload images from your gallery, or create a new photo post from a URL of a picture elsewhere on the web.

You can add tags, write a caption, and include a separate URL if you wish.

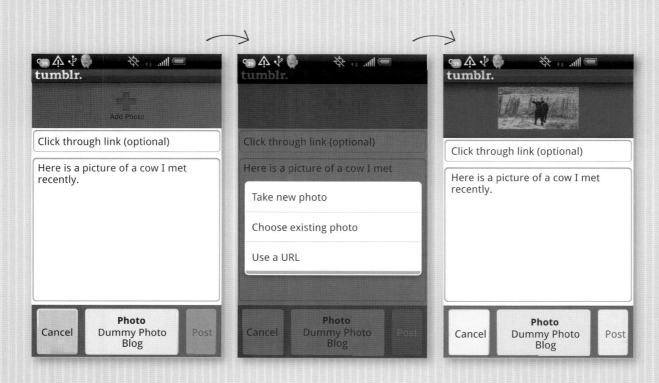

TUMBLR

Tumblr also has a range of themes, some more appropriate than others for photo blogging. From your Tumblr.com dashboard, go to "Customize." From there, you'll see options to set and modify the blog's theme.

 Like WordPress, Tumblr offers both free and paid themes, but it's easier to find low-cost "premium" themes, and they're much simpler to implement for the average non-technical user. Tumblr itself is also generally better suited to visual blogging as opposed to text-heavy blogging. Customizing colors is easy from within the Tumblr customization dashboard, and for the more technologically inclined, Tumblr also makes it simple to customize the HTML for your blog's theme.

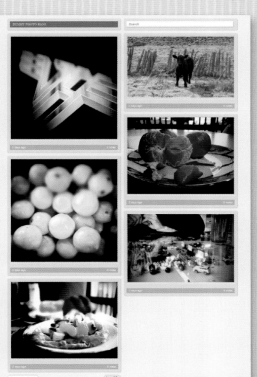

Solaris and ArtSheSaid are two free themes that simply and prettily display photos without too much clutter or distraction. The Effector Theme showcases large photos beautifully, and Cavalcade gives the viewer a scrapbook-like scattering of snapshots. Take your time in browsing through the free themes, and don't be afraid to customize the colors to better suit your work.

Shutterbug and Photofolio are great themes for the serious mobile photographer. Each theme will set you back a cool $49, but in return, you'll get a very elegant, inviting, and professional-looking layout for your images. These themes are also great if you plan to upload non-mobile digital pics to your photo blog.

PRINTING PHOTOS

Note on Printing Photos

If you've got photos you're particularly proud of and would like to share in a more physical context, you'll need to keep a few factors in mind.

Some apps automatically resize your photos into more web-friendly, smaller sizes. For printing images, you'll want the original pictures to be as large as possible. Vignette, a paid app we discussed earlier in this book, is one application that you can set to keep the size of your image at the maximum possible setting for your device.

When you're ready to print your pics, you'll have several options to choose from. You can always transfer your photos to a web-based service then to your computer or to your computer directly via USB to get the images you need and print them out.

Once the images are off your phone, you can print them on your home printer, or you can transfer them to USB and take them to a printing and copy shop. If you think your printing might need some trial-and-error finessing, this could be the best method to choose. Be sure to select heavy paper stock or even cardstock for your photo-printing projects, and always use the highest-quality printer available.

There are also apps for printing directly from your phone; most of these apps are for specific brands of WiFi-enabled printers. And you can also use mobile websites from real-world photo-printing facilities in your area, such as Walgreens or FedEx Office, to upload images for printing and pick-up.

You can also print out photos directly from Flickr.com. Prints start at just $0.09 each for a 4x6-inch photo and run up to around $9 for an 8x10-inch print. From the "Organize & Create" tab on Flickr.com, select "Prints & photo products." From there, you'll be able to use Flickr-integrated service Snapfish to select and order prints of your pics. Once you've picked out your prints, you can have them mailed to you, or you can choose to pick them up yourself at a nearby retailer, such as a Walmart or Walgreens. To be frank, this Flickr/Snapfish option is a lot less buggy than the direct offerings from FedEx Office and Walgreens, and I personally recommend it over those nascent services.

Then, there are Android and web apps that act as photo-printing services. Picwing, for example, is a subscription service that will print and mail your Android pics to you and/or your friends and family. For $6.95 each month, you get 15 prints sent to one recipient. Any prints you don't use that month are rolled over to the next month, and extra prints cost $0.19 each. You can upgrade your monthly subscription plan to increase the number of recipients.

ATION GALLERY

explored how to take, edit, and share
ing your Android device, here are 30
get your creative juices flowing.
an be found just about anywhere, and
your artistic medium in your pocket,
red to capture the beauty you see in
nd you even more than a traditional
vould be.
these intimate portraits, creative still
ntaking landscapes, and allow yourself
-then go out into the world and start
erpieces of your own!

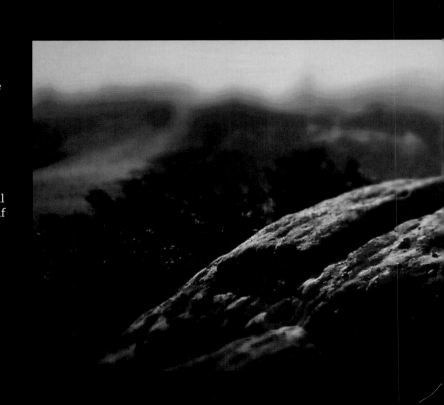

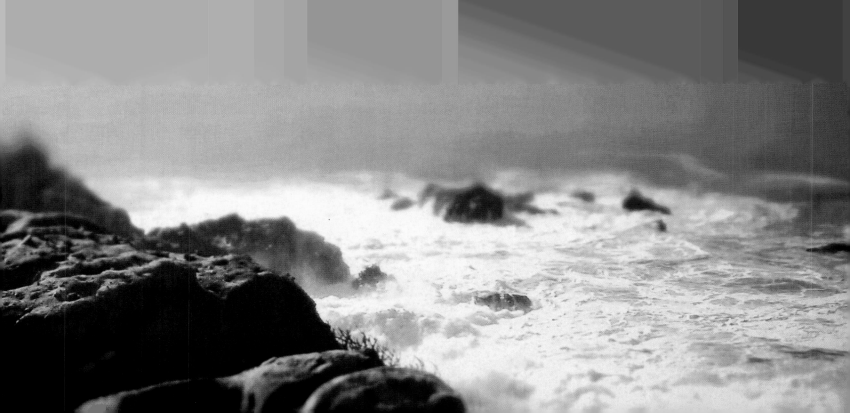

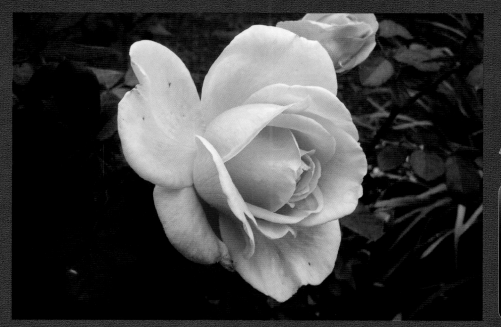

Device:
Captivate

App:
Native

Settings:
None

Photog:
Alan Teitel

Device:
Incredible

App:
Native

Settings:
High Contrast

Photog:
Robin Parker

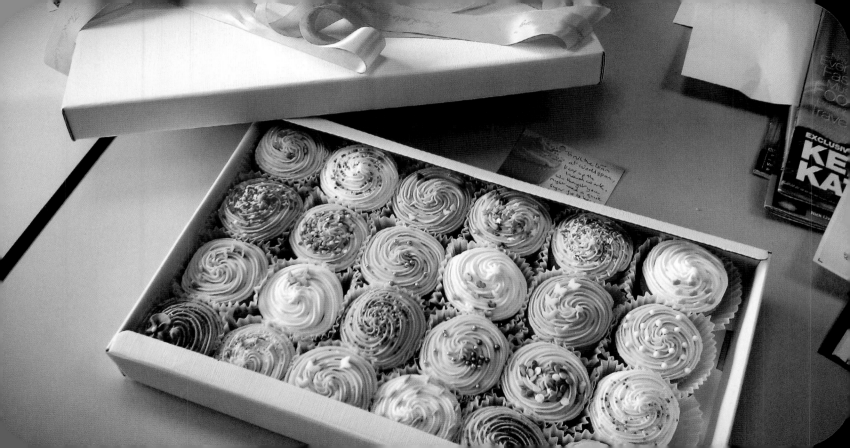

Device:
Droid 2

App:
Vignette

Settings:
Tilt-Shift,
custom

Photog:
Jolie O'Dell

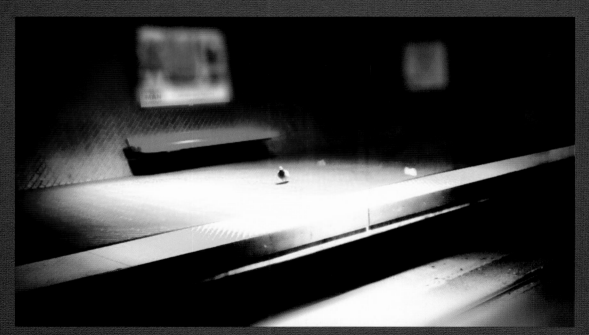

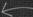

Device:
Evo

App:
Vignette

Settings:
Cross process,
custom

Photog:
Jolie O'Dell

Device:
Droid

App:
Vignette

Settings:
Velvia, Light
Leaks

Photog:
Joel Mandelkorn

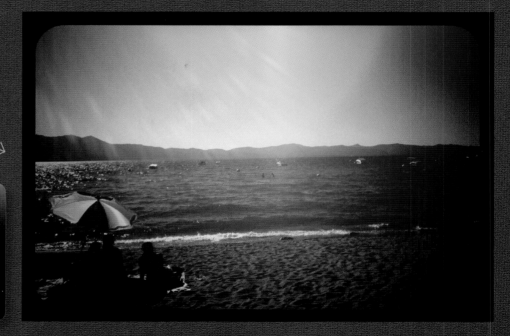

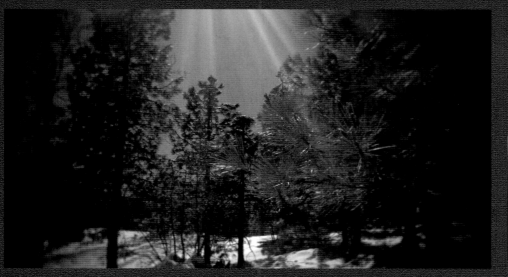

Device:
Droid X

App:
Picplz

Settings:
Little Plastic
Lens

Photog:
Marvin Fuller

Device:
Evo

App:
Vignette

Settings:
Cross Process
custom

Photog:
Jolie O'Dell

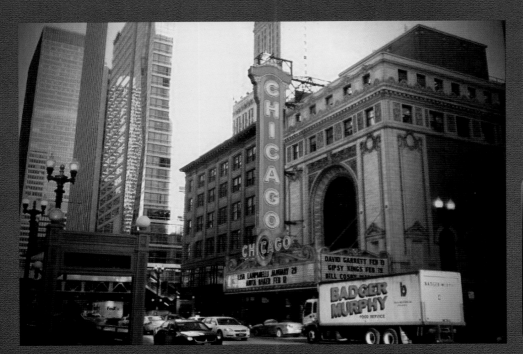

Device:
Evo
App:
FX Camera
Settings:
Vignette
Photog:
S. Hicks-Bartlett

Device:
Evo 4G

App:
Native

Settings:
Black and white

Photog:
Christopher
Munton,
Common Man
Films

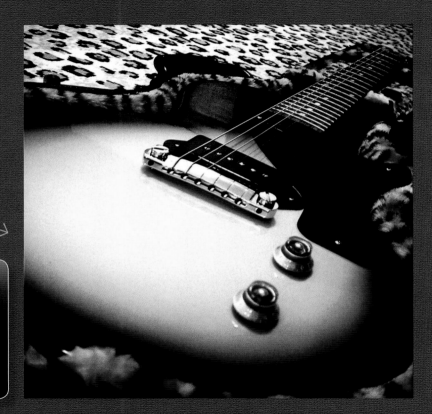

Device:
Evo

App:
Vignette

Settings:
Toy Camera

Photog:
William
Stimpson

Device:
Desire

App:
Vignette and
PicSay

Settings:
Generic Film &
custom settings,
Cross Process

Photog:
John Millar
(Dróid@Flickr)

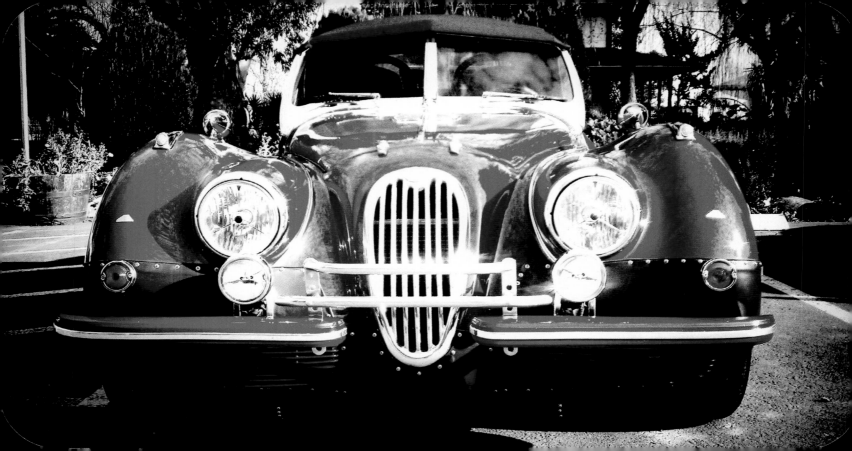

Device:
Evo

App:
Vignette

Settings:
Paris

Photog:
Jolie O'Dell

Device:
Droid

App:
Vignette

Settings:
Grad Tobacco,
Light Leaks

Photog:
Joel Mandelkorn

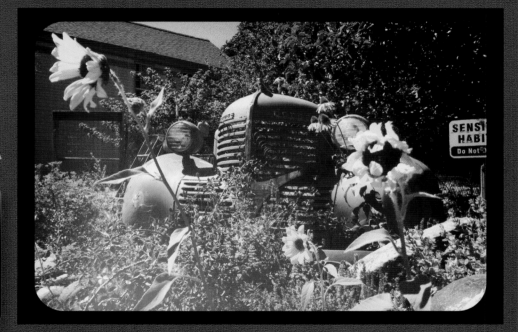

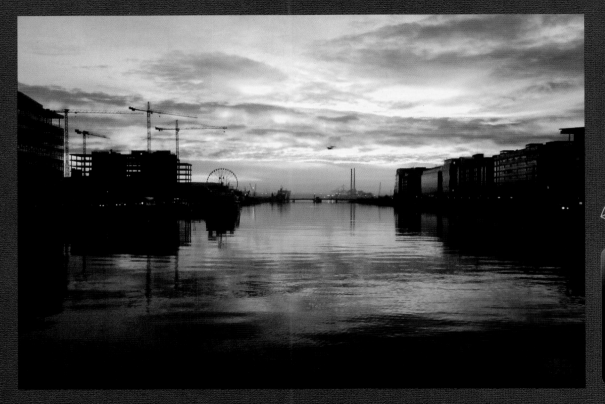

Device:
Nexus One

App:
Native

Settings:
None

Photog:
Marc Quinlivan

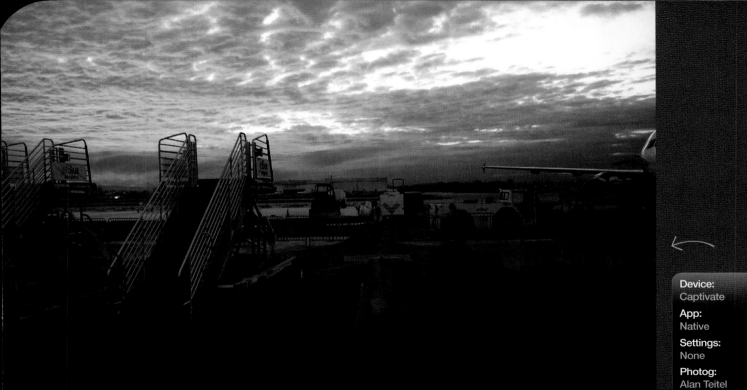

Device:
Captivate

App:
Native

Settings:
None

Photog:
Alan Teitel

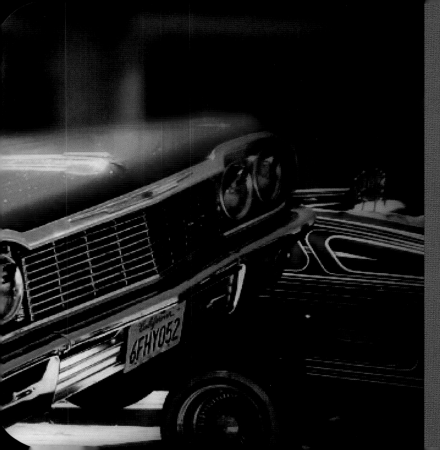
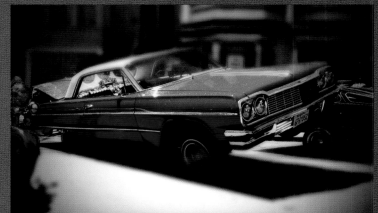

Device:
Droid X

App:
PicSay PRO

Settings:
Tilt Shift, custom

Photog:
Jolie O'Dell

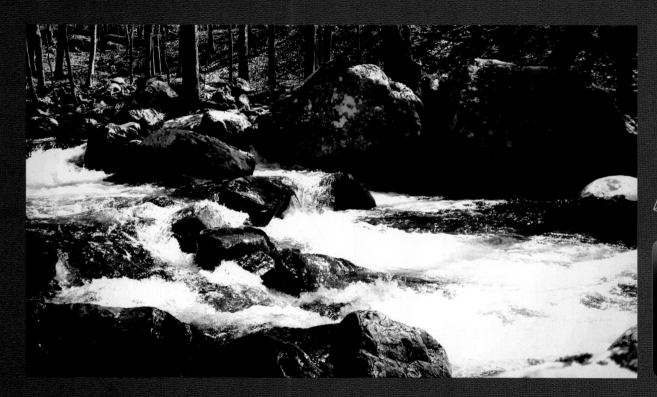

Device:
Evo

App:
Vignette

Settings:
Ilford, custom

Photog:
Jolie O'Dell

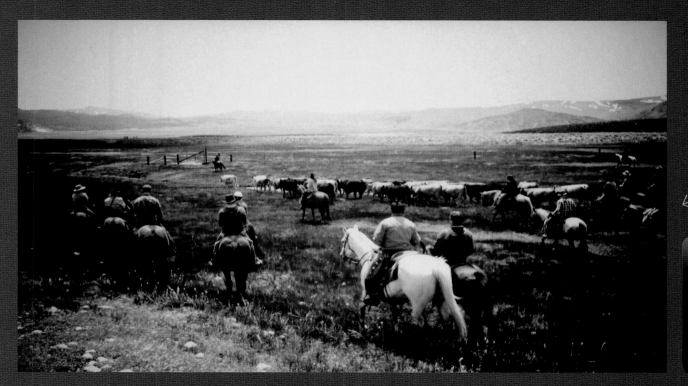

Device:
Droid X

App:
Vignette

Settings:
Palinotype

Photog:
Jolie O'Dell

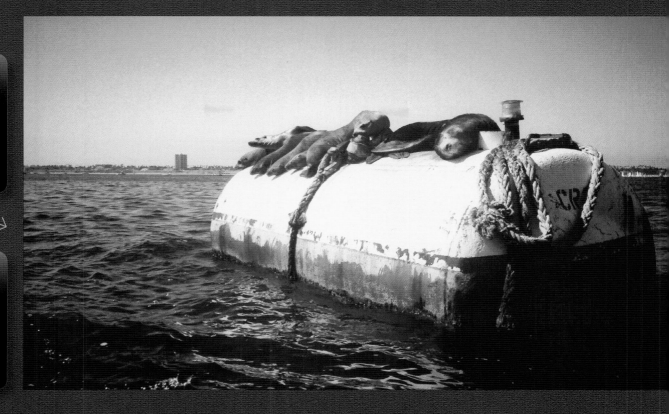

Device:
Droid X

App:
FX Camera

Settings:
Toy Camera

Photog:
Cassie Boorn

Device:
Droid

App:
Vignette

Settings:
Summer

Photog:
Joel Mandelkorn

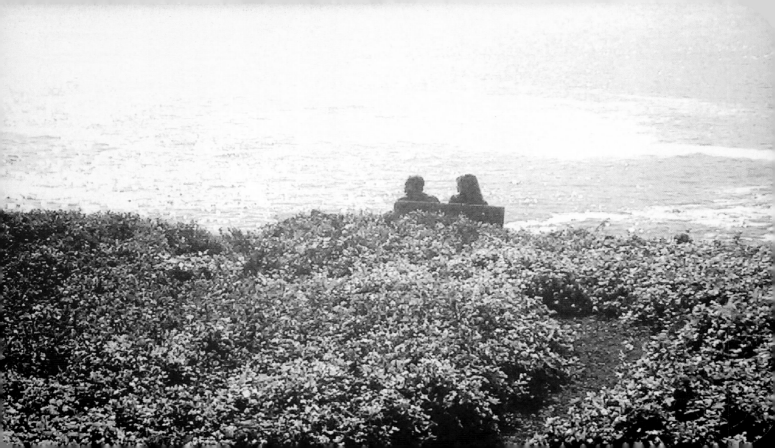

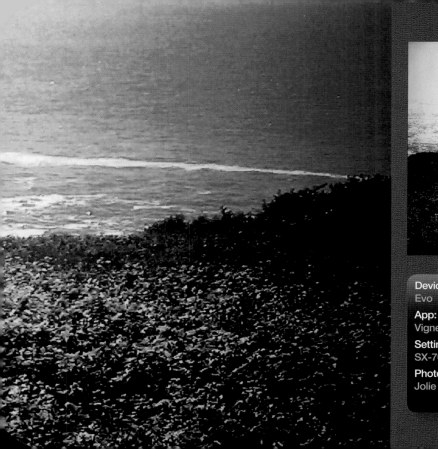

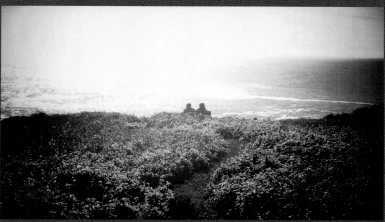

Device:
Evo

App:
Vignette

Settings:
SX-70, custom

Photog:
Jolie O'Dell

Inspiration Gallery

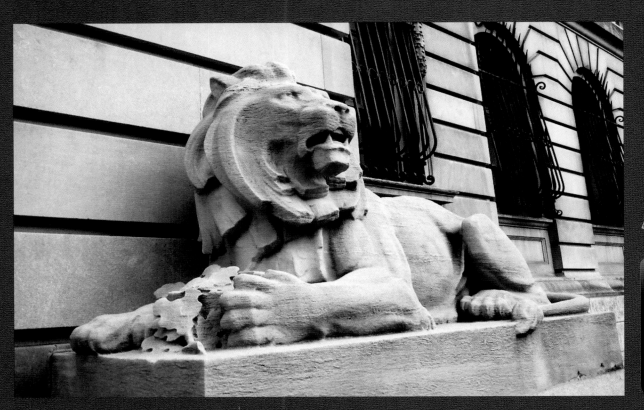

Device:
Captivate

App:
Native

Settings:
None

Photog:
Alan Teitel

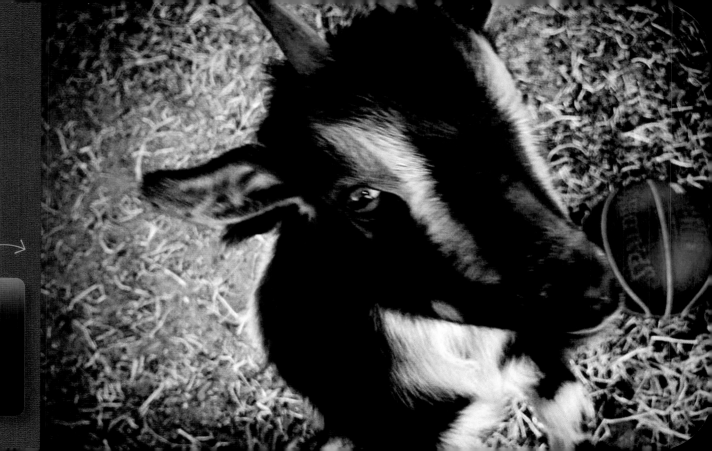

Device:
Droid X

App:
Picplz

Settings:
Russian Toy
Camera

Photog:
Marvin Fuller

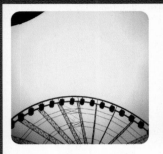
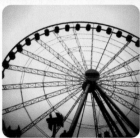
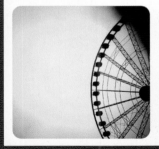
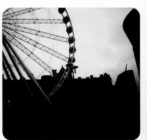
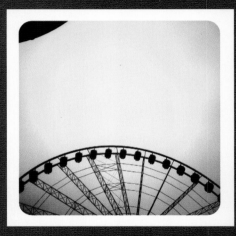

Device:
HTC Wildfire

App:
Vignette

Settings:
Summer, Square
Rounded Frame

Photog:
Simon Harrison

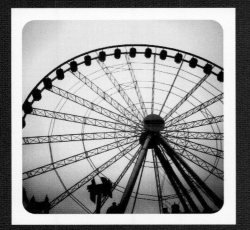
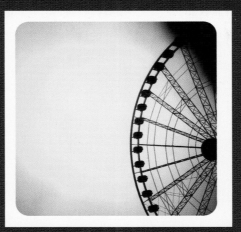
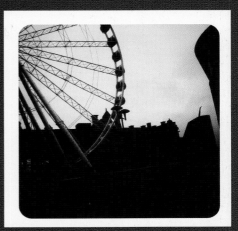

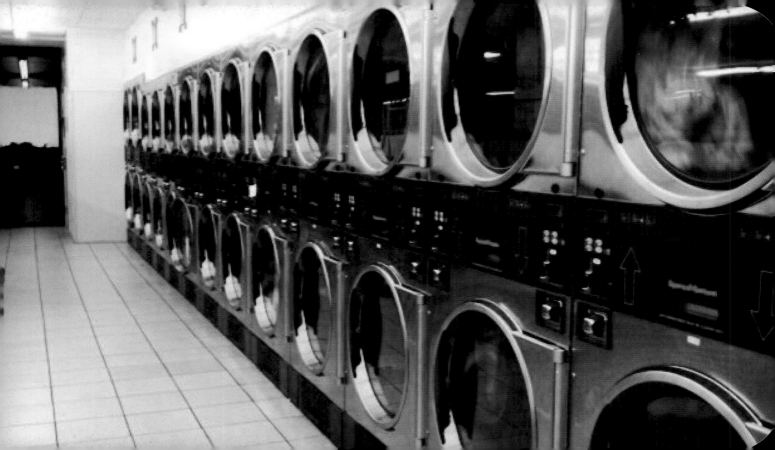

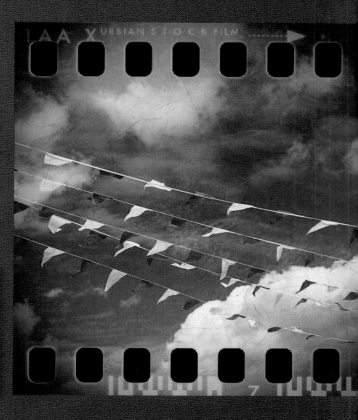

Device:
Evo

App:
Unknown

Settings:
Unknown

Photog:
Chrystine

Device:
Evo

App:
Retro Camera

Settings:
Pinhole Camera

Photog:
Chris Denbow

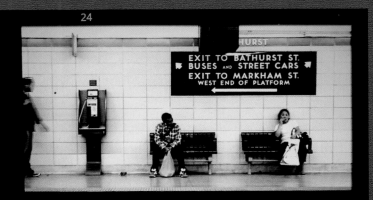

Device:
Droid

App:
Vignette

Settings:
Custom

Photog:
Nox Dineen

Device:
Droid X

App:
None

Settings:
None

Photog:
Alex Byers

Device:
Droid 2

App:
FxCamera

Settings:
Toycam

Photog:
Jolie O'Dell

Device:
Droid

App:
None

Settings:
None

Photog:
Danny Ayers

CHAPTER 6

SHOOTING, EDITING, & UPLOADING VIDEO

Mobile video is in a rather nascent state at the writing of this book and is likely to remain there for the next year or so to come. The reasons for this are wrapped up in hardware and network constraints. Only recently has shooting high-quality video and audio been possible; uploading these clips to the web has been quite the obstacle course in itself.

For most cases, if you want to upload video directly from your device, you will need to have your device connected to a WiFi network as normal 3G connections simply don't afford adequate bandwidth for significant data transfers. For this reason alone, real-time video uploading—or anything close to it—has been more or less impossible when shooting out and about in the real world.

But every month, we're seeing improvements and workaround solutions for the network limitations of mobile video uploading. First, we'll discuss in this chapter different hardware settings and apps for recording high-quality video and uploading it via a WiFi connection directly from your device and transferring video data to a computer for editing and/or uploading. Next, we'll take a look at some cutting-edge applications for recording and uploading real-time video from any network connection, even a spotty 3G connection. Finally, we'll talk about content—what makes mobile (or any other) video good video, especially for the web?

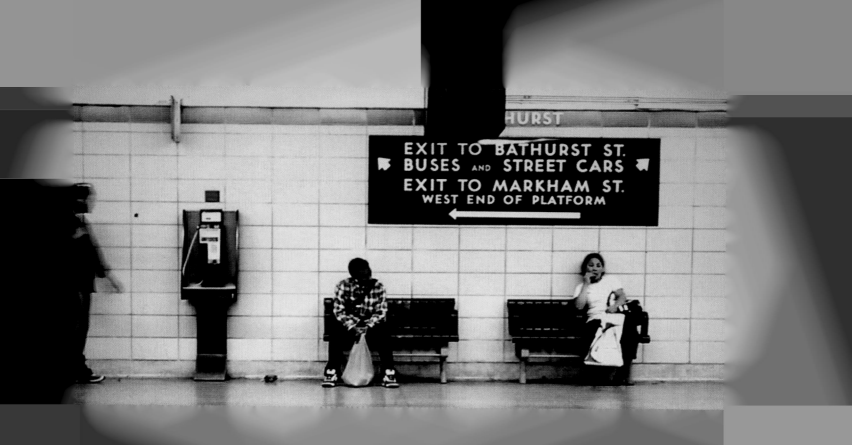

HOW TO SHOOT VIDEO FROM YOUR PHONE

The best way to find out what your device is capable of is to open your native camcorder app and shoot a few small clips. You'll get an idea for video quality, lighting issues, and sound quality. Some devices have multiple microphones, which can be great for noise cancellation when shooting video—especially impromptu interviews—in a crowded place.

Fire up your camcorder app and thoroughly explore the options and settings. Does the camcorder give you options for LED lighting for nighttime shooting or shooting in underlit environments? Are there "steadycam" settings to help mitigate jittery clips? Can you shoot for different file types? Your native camcorder might also allow you to adjust saturation or brightness of the video before you begin shooting, as well. Take a prolonged tour of the native camcorder settings before you begin committing anything to video.

If video is something you intend to shoot a lot (or even if you're particular about having non-jittery, non-handheld mobile photos) you might want to invest in some basic stabilization equipment. You have several options for inexpensive, phone-friendly tripods that can be used to great effect on tabletops or counters. You can even find phone mounts for traditional tripods, if you prefer shooting at eye-level.

When searching for a tripod, make sure you have your device's exact measurements handy so you know whether a particular piece of hardware will be a good fit for your Android phone. Read reviews carefully, and make sure whatever accessory you buy will work with your specific device.

Experiment in your home or office, as well as out in the world. Shoot in different lighting, at different times of day, with varying degrees of ambient noise, and at different distances from your subject. As with photography on your mobile, you'll find that practice makes, if not perfect, than certainly a great deal better.

Universal Tips for Shooting Great Video

Especially if your photo-sharing community has a large local following, it might be a good idea to get the gang together in person. Or if your community is largely virtual, there are many ways to get people involved using the web and the tools with which you're already familiar. You could, for example:

• Avoid backlighting.

• Eliminate as much noise as possible, and for this reason, don't shoot video in the wind.

• If you're holding your phone, place your elbows on a stable surface.

• Use the same guidelines for framing a shot as you would for a still photo composition; the Rule of Thirds and the Golden Rectangle still apply!

• If your subject is a person, allow for adequate space between the subject's head and the edge of the frame.

• When working with a human subject, the bottom of the frame should fall just below his shoulders, just above his waist, or just below his hips.

• Always do a background check to make sure there's nothing awkward or distracting behind your subject.

• If your shot is interrupted, keep shooting— you can edit out the interruption later.

• For interviews, try placing your tripod-held mobile off to one side, then allow the subject to speak to you directly; the result will be far more natural.

APPS FOR VIDEO
EDITING, & SHARING

h a new field,
and editing mobile
er and questionable
roid Market
(especially reviews
e type) carefully.

If you paid for an
app that doesn't work
well or that doesn't
work on your device,
return to the app's
Android Market page
within 15 minutes
for a full refund.

VIDTRIM

VidTrim is probably the most basic of all the mobile video editing tools. It's a simple app for shortening video clips you've captured. You can use simple sliders to choose where the clip should begin and end, then press the scissors icon. You can choose to trim and overwrite the original video or simply save the new, edited version as a separate clip.

 VidTrim Pro, which costs around $2.50, also allows for frame-grabbing and in-app sharing, as well as transcoding the videos to smaller file sizes.

CLESH

If you prefer a more full-featured video editor, your options are currently limited. Many so-called video editing apps on the market are buggy, crash-prone, and woefully beneath even the most modest expectations of features and performance. However, Clesh does have a few features worth noting; whether it's worth the $5 price tag is entirely subjective and depends on how much video you plan to shoot.

The app gives amateur videographers a window-filled interface—complete with a live chat support window—that will allow you to clip your shots as well as put multiple shots in the same video file. You can also use still images. You can upload your finished products to Facebook or store them on your mobile device.

Because the interface is extremely complex relative to most mobile apps' UIs, this is an app best for larger phones or tablets. And caveat emptor: Getting used to the features and interface takes time, and so do longer clip uploads. But you'll also have access to Clesh's web app, where you can explore more options and learn about the features on a larger screen with more accurate controls.

The app gives amateur videographers a window-filled interface that will allow you to clip your shots as well as put multiple shots in the same video file.

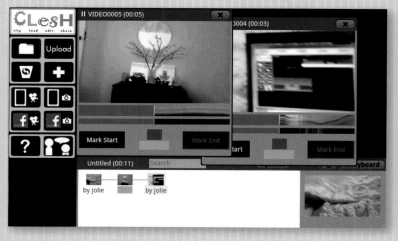

The Clesh app is powerful, but caveat emptor—the interface is also extremely complicated for a mobile app.

LAPSE IT LITE

Lapse It Lite is a clever app for those who would like to shoot time-lapse videos. Depending on the subject matter, these clips can be quite popular online, and Lapse It is a good way to make them quickly and easily from your mobile phone.

The interface is simple, and once your gorgeous time-lapse video is complete, you can upload it directly to YouTube from the app. Just be sure your battery is fully charged and/or your phone is plugged in if you're shooting an especially long time-lapse video.

Lapse It also comes in a paid version; for $1.99, users can capture full-resolution videos.

The interface is simple, and you can upload your time-lapsed video directly to YouTube from the app.

SAMSUNG VIDEO EDITOR

Finally, Samsung devices now have their very own video editor. If you are lucky enough to own a Samsung-manufactured Android device, head to Samsung Apps (there should be a native shortcut to this homegrown app store on your device), and look for an app called Samsung Video Editor. It offers basic transitions and effects and represents a step up from what's currently available on the Android Market.

HOW TO UPLOAD VIDEO FROM YOUR PHONE

Depending on your network, your geographical location, and your device's capabilities, your experience in uploading video directly to the web will vary greatly. If you're fortunate enough to have reliable 4G coverage, for example, you might have a much better time of it than a user on a lesser network. In most cases, however, your best bet is to either seek out a WiFi connection or transfer your files to a computer before uploading.

In your phone's settings, you should see an option to adjust your networks and connections. From here, you'll want to choose to connect to a WiFi network. You'll then have to choose from available networks and perhaps enter a password. Opposite you can see how those dialogs look like on an HTC Evo; you may have different settings on your device.

Once you're connected, your upload will still take much more time than other types of data transfers. On average, a video's file size is many times greater than that of a photo of even the highest quality. Be prepared to wait a while for the upload to finish.

Here are a couple important caveats: Don't start an upload you won't have time to finish. In your experimentation, try uploading video from your home's WiFi network; take note of how long it takes you to upload different clips of varying lengths. Use those measurements as a rule of thumb for uploads on other networks, keeping in mind that other networks may take more or less time depending on how fast they are inherently and how many other users are on the same network. And most importantly, know that video shooting and WiFi usage both take a heavy toll on your device's battery life. Have a full charge before you start, and bring a charger or extra battery (or both) along with you if you plan to have a video-intensive day.

APPS AND ONLINE DESTINATIONS FOR UPLOADING VIDEO

Once you've got your clips shot and edited, you'll want to put them online, if only to test your efforts on a slightly larger screen, and perhaps to begin sharing your mobile videos with the world. Where you choose to post your clips will depend a lot on what kind of content you've created. More personal clips of you or your family will require a slightly different presentation than interviews you might conduct, or more artistic clips.

Without question, YouTube is the largest online destination for video clips of all kinds. Setting up a YouTube account is free, and you can upload clips (or shoot them directly) from the official YouTube Android app.

One of the best reasons to use YouTube is that the site connects well with all your other online destinations. For example, if you're accustomed to sharing your mobile photography on Facebook, YouTube meshes well and will allow you to seamlessly integrate your mobile videography, as well. If you're a mobile photography blogger, YouTube videos are almost universally embeddable in most blogging platforms.

YouTube will also let you track statistics on your videos, including who's watching and how long they watch before they tune out, through a feature called Insights. Or, you can just measure your success by the number of views on each video.

However, YouTube's interface isn't the most elegant. Many amateur and professional video artists and filmmakers prefer to use Vimeo, which gives users a prettier, pared-down interface along with most of the features you'd see with YouTube clips, include simple sharing and embedding tools.

But as an Android user, you might not find Vimeo as easy to use from your device as you would YouTube. Vimeo apps do exist in the Android Market, but many of them are still in early releases and quite bug-ridden. Expect this to change over the next few months, but read app reviews carefully, especially if you're springing for a paid or non-official app.

Dozens of other online platforms for video-uploading exist. Which platform you choose largely depends on personal aesthetic features that matter to you, and whether or not you need the network effect of a large platform to get a lot of views for your content.

Facebook itself might seem like the ideal destination for sharing your mobile video clips, especially those of a more personal nature, but currently users don't have the ability to upload video directly from the Facebook Android app. However, a quick search in the Android Market will reveal a slew of apps for uploading video to Facebook—just be sure to read reviews, and be sure you understand the permissions each app will need.

For photo bloggers, check your blog software's Android app, since many apps will also include options for uploading video directly from your phone to your blog.

Without question, YouTube is the largest online destination for video clips of all kinds. Setting up a YouTube account is free, and you can upload clips (or shoot them directly) from the official YouTube Android app.

REAL-TIME RECORDING & UPLOADING

One exciting and quickly evolving area of mobile videography is real-time video streaming. In this paradigm, video captured on your Android device is uploaded directly to the web as it's being shot. This is the perfect option if you're trying to get quick clips of on-the-ground action to the web in a hurry, and the format can work well for many kinds of content, from a baby's first words to the winning point at a ballgame to a riot or other crime in progress.

Because of the immediacy inherent in these platforms, most of them have built-in social components. These features make it easy for you to get a large group of your friends watching your content as it's happening.

The quality of your video may depend a lot on the quality of your network's signal when and where you're shooting; however, most of the real-time, streaming video apps have optimized for better frame rates, smoother shots, and better quality overall. In general, quality will be best when your connection is strong, and it will degrade slightly when your connection is weaker.

Android Photography

Shooting, Editing, & Uploading Video

One exciting and quickly evolving area of mobile videography is real-time video streaming.

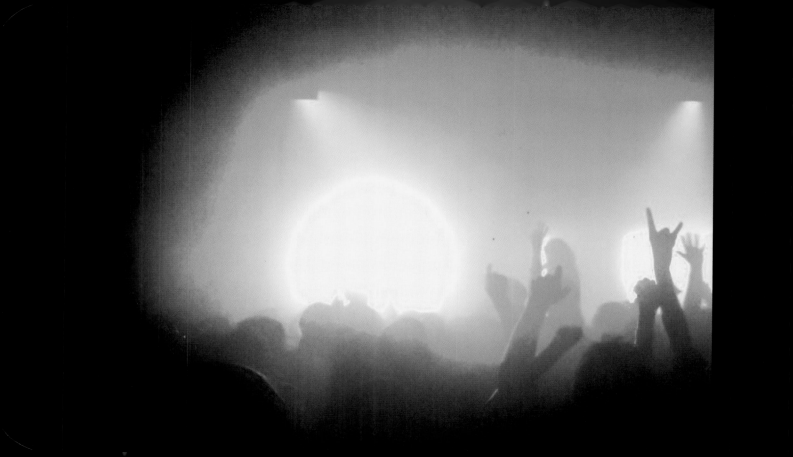

USTREAM

Ustream is the quintessential and perhaps simplest app for streaming live video from your phone. It's not bedecked with too many features, and for live streaming, it gets the job done. Once you've fired up the app and logged in, you can start streaming video to your Ustream page right away. You also have the option to share your live stream's URL on Twitter and/or Facebook, and you can re-share the same or a modified status and link at any point during your broadcast.

During your live stream, you can monitor chat messages from your viewers. You can also poll your viewers and have them register yes or no responses, which then appear in a small bar graph at the bottom of your screen. Videos can be saved or discarded when the live stream is over.

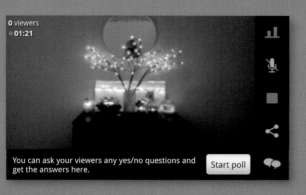

You can ask your viewers any yes/no questions and get the answers here.

Start poll

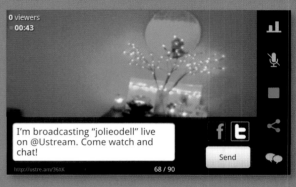

0 viewers
00:43

I'm broadcasting "jolieodell" live on @Ustream. Come watch and chat!

http://ustre.am/36XK 68 / 90

Send

QIK

Qik is a mobile video offering from Skype. This app will let you do live video chat (of course) or upload streaming video from a 3G, 4G, or WiFi connection. The video chat features work between almost all Android and even iOS devices, including the iPhone and iPad. Videos that are streamed live to Qik.com can also be posted to Facebook, Twitter and other destinations. Video messaging is also part of the product, albeit on a trial basis.

 Qik doesn't work on Android tablets just yet, but it is supported on devices with Android 2.1 and higher.

SOCIALCAM

One of the forerunners and current leaders in real-time streaming video is Justin.tv; Socialcam is this company's mobile offering. True to its name, it offers a very social experience for creating mobile video. For one thing, it allows you to easily connect to all your Facebook friends who are also using the app. It also prompts you to share your videos on Facebook once they've been uploaded.

Once the video is uploaded, it lives in perpetuity on a unique page you can share anywhere online. Also, you can use the app to view videos from any of your friends.

MORE HARDWARE & ACCESSORIES

Even the best Android devices could use a little boost. If you're trying to get faster uploads or a better viewing experience, you might want to check out a few external options.

The one Android accessory that would be most welcome to mobile videographers—especially those shooting a lot of interviews—would be external mics. However, Android software doesn't currently support external microphones. This may change in the months or years to come, however.

Editing and Uploading From a Computer

If trying to edit and upload from your device is a consistent exercise in frustration—or if you simply want to get more done and get it done faster—you should consider transferring your video files from your Android device to a laptop or other Internet-connected computer.

In all likelihood, your Android device was packaged with a micro-USB to USB cable; if not, you'll need one to get your files from one piece of hardware to the other. Plug your powered-up mobile into your computer with the cable; pull down the status bar to see your USB options. Initially, your device will probably plug in with a "charge only" setting. For this exercise, you'll want to select that option and switch it to mount as a disk drive.

Once the mobile is mounted, you'll be able to browse through your phone as you would through any other part of your computer's hard disk or other drives. You will find your video clips in the folder with your still images, typically named DCIM, or in the folders corresponding to your video-capturing apps. Once you locate the videos, drag and drop them to any convenient folder.

or Final Cut. Ultimately, you must choose the software that works well for your purposes and fits your budget best.

From your computer, you can upload finished videos to almost any video destination online; your options are hardly limited. Just make sure you export your videos into a web-friendly format and size.

Video Out
If you want to see your works on a large screen for viewing rather than editing purposes, there are a few options. What options you, yourself, will have largely depend on what device you're using.

Some of the higher-end and media-focused Android devices have HDMI outputs. These can be plugged into any television set or other monitor with an HDMI input. In other cases, you might be able to use specific apps to get your video from one screen to another wirelessly. Skifta is a fairly new app that will let you send all kinds of media—including video, music, and still images—wirelessly from your Android phone to any number of computers, PlayStation consoles, or other connected devices in your home.

WHAT CONTENT WORKS?

For mobile photography, there's already a pretty established canon of categories for subject material. Pets, food, landscapes, found objects—instinctively, the amateur mobile photographer knows what will make a good photograph. And with practice, he or she knows what will get the most views, comments and shares from friends. But when it comes to video, the types of content your friends will want to see might be slightly different.

Storytelling is a key component of moving pictures. It's true that a picture is worth a thousand words, but when you're shooting video, unless you're creating some very artistic cinema, your clips should have a discrete arc. A beginning, a middle, and an end. A cohesive and very obvious story.

Before uploading or even shooting a clip, consider what kind of story you're trying to tell. Are you trying to share something you've just seen out and about? Are you trying to capture a moment shared with your friends or family? Are you relating something that's happened to you personally? Are you trying to bring out a unique aspect in another person? Ask yourself, "Why will this story be better as a video than as a picture?" Make sure your clip plays up those story-telling elements as much as possible.

When shooting any kind of video with people, even if it's just you, yourself, be as natural, real, and authentic as possible. If you can manage to be consistently genuine, you'll avoid many of the pitfalls and vanity traps of mobile videography.

Also, remember that others will be watching and interacting around your video. In the best-case scenario, you'll be able to invite your friends and other viewers to participate in conversations and comments around the video.

Another tip for creating great, watchable video—especially video that gets more views—is to remember the principles of newsworthiness. These guidelines aren't just for news articles; they apply to all kinds of content. Basically, they state that content is newsworthy (i.e., people want to watch it and consider it interesting) if the content has aspects of novelty, celebrity, timeliness, conflict, impact (either generally or locally), etc. Do a web search on news values to get a better idea of what makes certain types of content appealing to mass audiences.

Another tip for creating great, watchable video—especially video that gets more views—is to remember the principles of newsworthiness.

YOUR NEXT STEPS INTO MOBILE PHOTOGRAPHY

Your Photo-Sharing Community

As a creative Android photographer, you're probably sharing your photos and videos online, and people—your friends and family as well as complete strangers—are interacting around them. In fact, mobile photography is by its very nature linked to the Internet, and thus linked to a vast network of people who read and view content and want to interact around it.

Whether you planned it or not, you've created a community around your images; a sphere of people who are interested in what you're saying through your pictures. The community might be a private one of just family and close friends, but it's still an entirely new group.

Some of you, on the other hand, do want the extra attention! You've got something important to say, or you just love expressing yourself artistically through your photos. And as you share them—and as your skills improve—more and more friends and strangers will show up at your various online destinations to comment on and converse around your work.

Either way, every person's photos create a fluid community of like-minded individuals who are interested both in your photos and in you. And it's quite likely that most of these individuals will want to learn more about both.

THINGS GOOD COMMUNITY-BUILDERS DO

Tell people what apps and methods you use.
Your community will very often include other photography enthusiasts and Android device owners. They'll definitely want to know what kinds of apps and setting you're using to get particular effects in your images. Don't wait for them to ask; always include some information on your device, your app of choice, and any applicable settings in the image caption.

Respond to comments on your social profiles or photo blog.
If friends or strangers are leaving you comments, especially if those comments are complimentary, it's only polite to respond, even if all you have to say is a simple, "Thank you."

Ask the community for help, resources, and tips.
When you run into trouble, whether your Evo battery life is abyssmal or your Droid native camera won't focus, turn to your friends online for help. In all likelihood, anyone with your device has been experiencing the same frustrations and may have found a fix. Your community can also guide you to fresh inspirations, good photogs to follow, more editing and composition tips, and a lot more. All you have to do is ask.

Curate a great list of tips and resources, yourself!
As at least one good book says, "It is better to give than to receive." If you've picked up tips of your own here and there, or if you see a consistent issue in the photos being shared in your own social circle, feel free to share your knowledge on your blog, website or Facebook page.

Invite others to participate with you

Especially if your photo-sharing community has a large local following, it might be a good idea to get the gang together in person. Or if your community is largely virtual, there are many ways to get people involved using the web and the tools with which you're already familiar. You could, for example:

1. Organize a photo walk in a particularly scenic area or building.

2. Give your friends online a daily photo challenge.

3. Set up a photo scavenger hunt that can be conducted either online or in person.

Your community can also guide you to fresh inspirations, good photogs to follow, more editing and composition tips, and a lot more. All you have to do is ask.

THINGS GOOD COMMUNITY-BUILDERS AVOID

Don't harshly judge others' work.
Raining on someone else's parade might point out the flaws in someone else's photograph, but it is more of a reflection on you. Use this common-sense dictum: If you can't say anything nice, don't say anything at all.

Try not to post anything and everything you photograph.
You may be a prolific artist, but it's not a good idea to publish every single photo you take, regardless of how cool, artistic, or interesting each snap may seem in the moment. Learn to self-edit, and only share your best pieces. Editing can be excruciating, but it's a character-building exercise that helps you better understand the real value of your images.

Don't post more than a couple pics or one blog post each day.
If there's one quick way to turn off your budding community, oversharing is it. The fewer your posts, the more precious and anticipated they may become.

Never lose your humility and willingness to learn.
There will always be new apps to adopt, new tricks to pick up, new locations to scout, new angles to try. Don't become stuck in your ways or think that your particular style is best. Always be willing to learn and adapt.

Don't incessantly post pictures of yourself.
You are your own most available model, so there's some temptation to overindulge in self-portraiture, if only because it's so darned convenient. But find other muses, too, and your photos will become more interesting to a wider audience.

Try not to "pose" yourself or your friends too much—be real.
In most circumstances, a natural and candid pic will trump a staged one. And if you do prefer staged photos, try to make sure at least the faces of your subjects are relaxed and natural. I suggest catching your subject off-guard if he or she tends to "pose" too much.

Don't share images without clear descriptions.
Especially if your friends won't see a thumbnail first, as is the case with some social-media sharing, you'll want to give your community a clear idea of what they're in for if they click that link.

Never post obscene or mature content without advance warning.
Depending on the platform, you may not be permitted to share "adult" content on your account at all. When sharing online, check the Terms of Service for the apps you use. And legalities aside, remember that there are children and more sensitive viewers out there on the web; think twice (and think empathetically) when considering posting an image that might be offensive.

Never post hateful content.
Finally, it should go without saying that hateful content shouldn't ever come from a conscientious community builder. Take the feelings and diverse points of view of your audience into account when posting new images or videos; always post what is interesting, noteworthy, or uplifting to that audience.

RESOURCES

Flickr Groups

One of the best features of photo-sharing site Flickr is its groups. Groups (and pools) allow the service's like-minded users to congregate and share content around themes or topics. Flickr has several groups for Android photography; in fact, there are entire groups for single apps such as Vignette. Flickr Groups are a great way to get inspiration, meet other photographers, and discuss issues and techniques unique to Android photography. Add the photogs you meet there as contacts on the site, and keep up with their postings, making sure to comment on and ask questions about their pictures as warranted.

Android Market Website

The Android Market website is another go-to resource for Android photographers. Particularly when you're researching new applications, the site's wealth of reviews and screenshots will come in handy. You can peruse the apps on your mobile, as well; but sometimes, a bigger screen and a faster connection can greatly enhance the app-research process.

AppESP

When you'd like to try new photography or videography apps but don't know where to start, head to the Android Market and pick up a free download of AppESP. This application will comb your phone, figure out the kinds of apps you enjoy, and make personalized recommendations for new apps for you to try—kind of like how Amazon.com's recommendations work. When AppESP finds new apps for you to try, it will send a discreet notification to your phone, and you can "like" or "dislike" applications in AppESP to get even better recommendations.

Mashable.com

I may be biased (since this blog is also my employer), but Mashable.com is a great resource for Android news, Android hardware, and mobile photography tips and galleries. To get updated on just the most relevant posts, login to the site and "follow" the Android and Photography topics. That way, any pertinent articles will be flagged for you in the "My Stories" tab at the top of the site.

ADIDAP.com
"All Day I Dream About Photography" is, as the title implies, all about photography, not so much about technology. Still, the Photoshop tutorials and creativity-jolting photographs might be a welcome addition to your daily reading. Check out the site for how-to articles, interviews, news, and a lot more.

PicturePundit.com
PicturePundit.com is a good resource for the technologically-inclined photographer—especially if you're thinking of going into photography as a full- or part-time business. The author is photographer, blogger, technophile and news junkie Aaron Hockley, and he strives to keep readers updated on relevant topics.

Androinica.com
To keep up to date on all things Android—and only Android, not necessarily photography—check out Androinica.com. This blog features news and reviews on hardware, including phones and tablets, and software, including OS updates and, of course, applications. To hone in on the latest and greatest photo apps, simply search the site for a keyword such as "photography."

ShutterSisters.com
If daily inspiration is what you seek, ShutterSisters is the blog for you. This publication is a group effort and counts 14 women as its contributors. The blog makes a point of recognizing and speaking to female photographers and its articles and "Daily Click" featured photographs will give you plenty of creative nourishment.

Pixiq.com
This site offers news, tips and resources for all kinds of digital photographers. It includes general advice on how to find good lighting or better compose a shot, and it has news on hardware and apps, too. And its galleries offer tons of inspiration.

INDEX

Jolie O'Dell is a technology journalist and longstanding Android enthusiast. She's been doing mobile photography personally and professionally since 2007. As a newswoman, Jolie has also had to learn a bit about photography and photo editing for newspapers, magazines, and online news outlets. Her photojournalistic creations have been featured in tech and news publications internationally over the past decade.

When she's not snapping pics of her friends, her travels, or her culinary adventures, Jolie enjoys software programming, music-making, and rollerskating around San Francisco.

Jolie wishes to thank her family, without whose love and support the writing of this book, like so many other endeavors, would have been impossible.